MW00681909

Published by White Falcon Publishing Solutions

Photographs and Text by © Parabjeet Singh
Photograph on Page 04 © Abhinav Sarna
Photograph on Page 80 © Sarabjeet Singh
Text Editor: Mahalakshmi Prabhakaran
Design and Layout: Parminder Matharoo

ISBN: 978-1-63640-189-8

*This book would not have been possible without the
support and encouragement of Archana Mittal, David
Crimson and Vidya AP.*

*Each of you have an integral part in the making of this
book and you have seen me through my struggles and
successes. That is true friendship. Thank you.*

*I would also like to thank my family for always
supporting me in everything I do.*

PREFACE

Light is a book about the people I met and
lessons I learnt during a difficult period in my
life. The 15 stories featured here, with
photographs completely shot over the course
of 2020, mean a lot to me because when I look
back at that time, they were the light at the
end of my tunnel.

I hope these stories inspire and make you
believe in second chances as they did for me.
This book is dedicated to life's surprises.

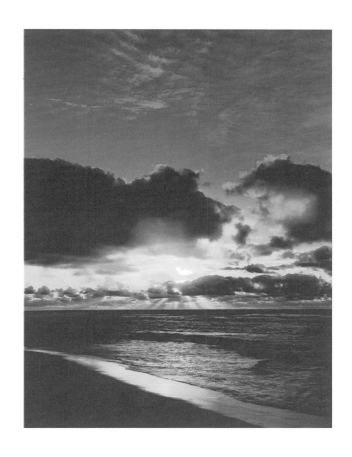

PHOTOGRAPHER
FOR HIRE

I'd just scraped through a terrible year; with failed relationships, an endless creative block and the dwindling self-worth of a potato, you could say I was running away from a demon or three (and not doing a very good job of it).

So, when I rang in 2020, I had a fool-proof plan of how it would pan out. After what I'd been through, I needed a break, a long one. With my bags packed, studio shut, responsibilities on hold, I was all set to travel the world. I couldn't wait to create new memories and experiences.

First stop, Perth, Australia.

Two months in and I was on a perpetual hangover. Apparently flying thousands of miles away didn't take you further from your problems, who would have known! Anyway, I was scheduled to fly to Japan soon and was really looking forward to it. Sushi would do the trick, but boy was I in for a treat. Along came March, 2020. Need I say more?

I had to bid goodbye to my impeccable plan. My life had just swerved from a fabulous holiday into a crash landing. A rude awakening perhaps, but it felt more like the creator's satire. Who better than me for his jester.

The three-month visit to Australia now stretched ahead for the unforeseeable future. International travel was prohibited so I couldn't get back home. Perth is an expensive city. Things weren't looking favourable for me especially without an income. I had no choice but to spend my remaining holiday money to get a student visa and do odd jobs to make it work. And it did for a while, but I was staring at the decision to sell my equipment just so I wouldn't go penniless. It made my head spin, but I logged on to the classifieds to do just that. That is where a Photographer for Hire ad jumped right out at me.

And that is also where my story took a right turn…

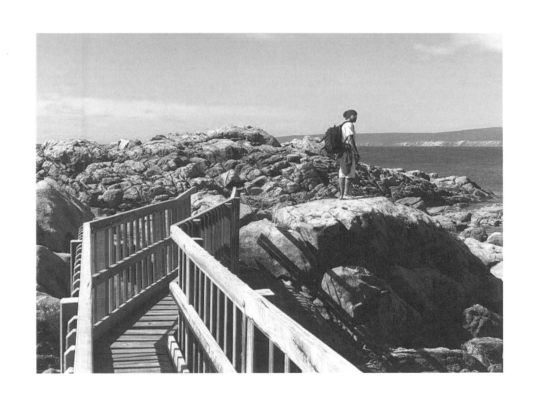

Jeremy Atlan

—

Captain J as I fondly called him, came into my life when I was broke, clueless and completely alone. He was, in the metaphorical sense of the word, the light that shined my way forward. It was an ad that Jeremy had placed for a photographer that brought us together. My memories of our first meeting are of me sitting nervously with my resume and laptop while he interviewed me for his company - 3P Photography, which specialises in school photography. For an interview that was meant to be about the job, we hardly spoke about photography. Unusual, I know.

During my first few days at 3P, commuting to work and shooting locations was proving to be an issue. I knew I had to buy a car but I didn't have enough money for it. Public transport seemed to be the only option available so I asked Jeremy if I could start work once public transport services resumed. His answer was a straight 'No' before he followed it up with a quick solution. *"I will give you a car to travel and deduct the cost from your paychecks."* I hadn't thought of that at all. Actually, come to think of it, I hadn't thought that someone would go that extra step to make their employee's life easy.

Over the course of my time at 3P, Jeremy turned out to be a great mentor, colleague and friend who had a shared interest in heavy metal music and drinking beer in industrial quantities. One of the most badass guys I know, Jeremy was the boss who became one of my favourite humans in Perth.

"I need you back in Perth," is what he tells me every time we speak today.

Georgia Page

—

"It sounds easy from the other side of the camera!"
she laughed. And I couldn't argue with it. As a
photographer, you are directing the model to do
what you want and it is up to the model to 'get'
you. Georgia Page got me.

Georgia is not your typical model. And her life...
it doesn't subscribe to life's regular rules. A care
worker at an aged care centre in Perth, Georgia
battles, among other issues, with Ehlers-Danlos:
A lifelong illness so unpredictable that you could
wake up with chronic pain one day and blotches
all over your body the next. It's an ailment that
can limit the way you live your life.
But the model I met that day wasn't a patient.

"Stretch marks, bruising, hair loss, visible veins,
physical limitations and bigger mental ones,
I live with them all. I try to hide them thinking it
will all get back to normal but I know that normal
doesn't exist for me. I have chronic pain and this
is how I look."

Georgia turned out to be the perfect model I
could have asked for. She made me feel
comfortable and did exactly what I wanted her
to do in this street-style shoot: Listen to my
instructions and react.

A fighter in the true sense of the word, Georgia
taught me that the light in our lives lies in the
small, simple, thoughtful things we do for
ourselves and others.

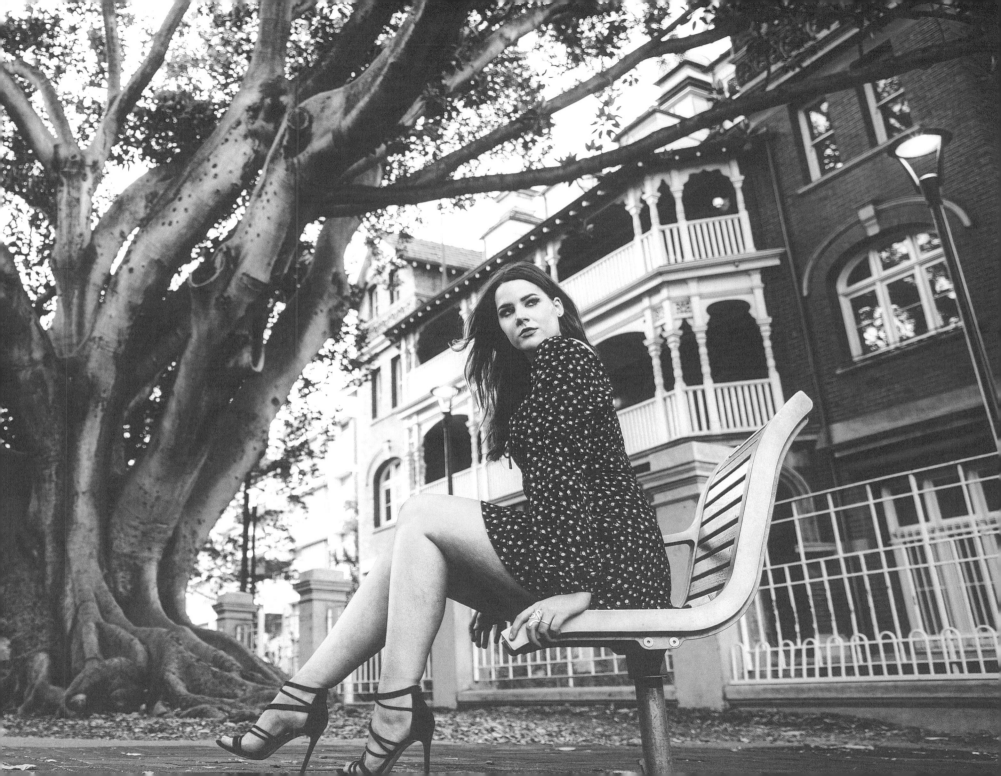

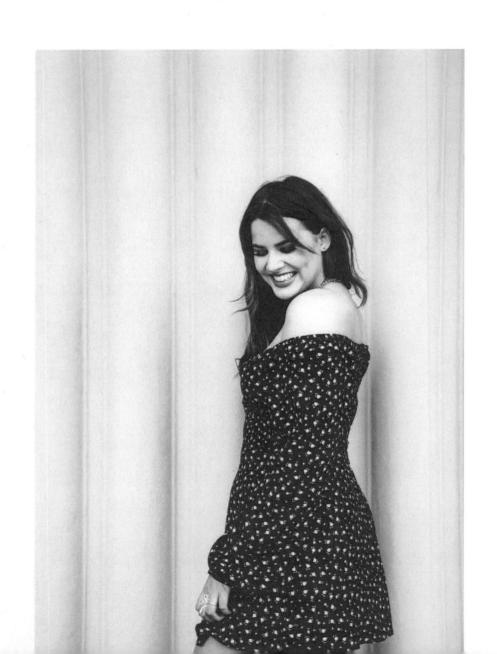

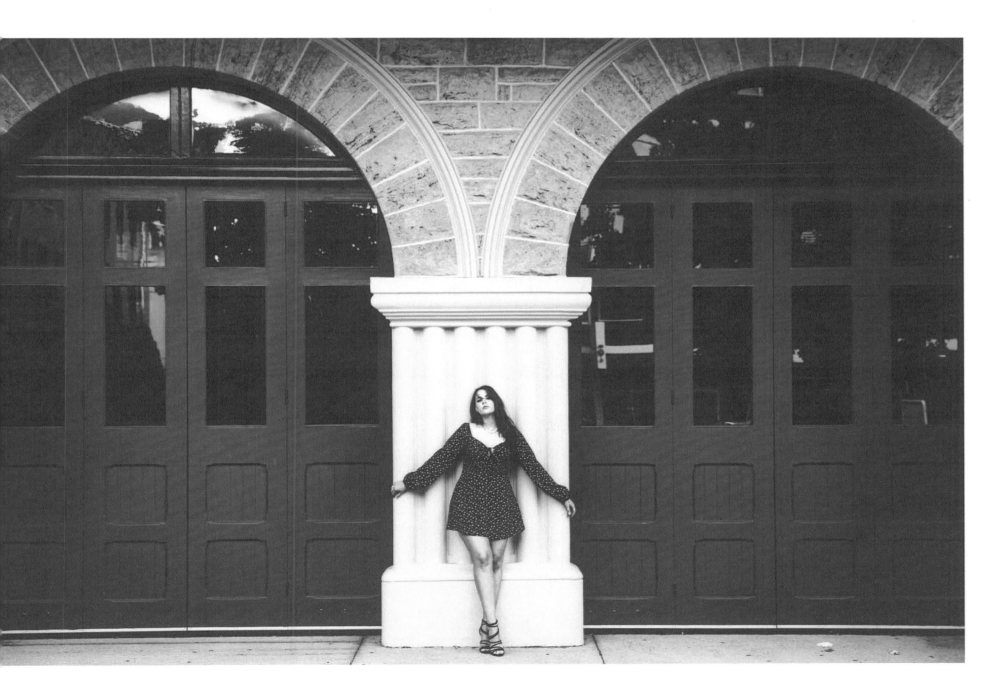

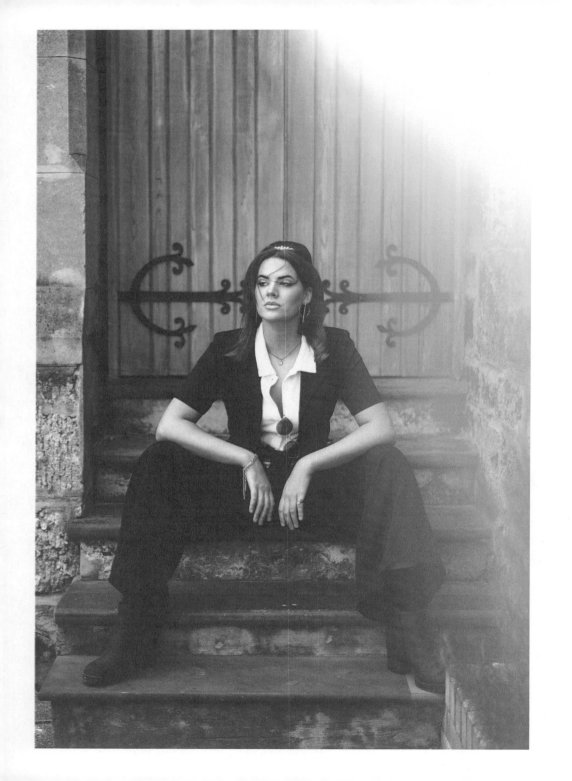
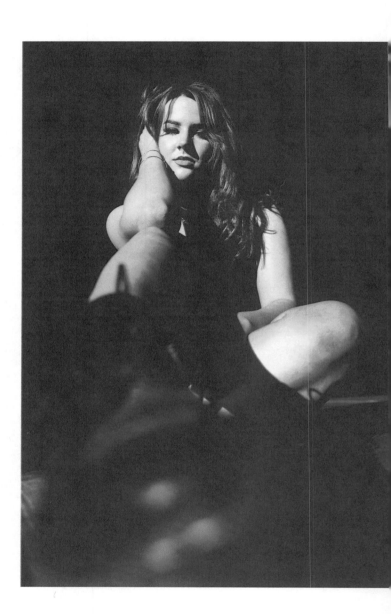

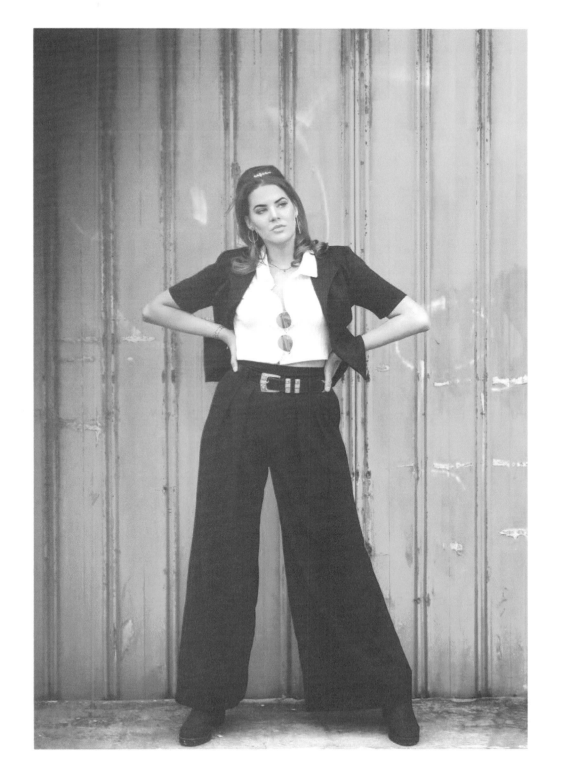

PASSION

—

Drew Holloway

—

I've been passionate about a lot of things in my life — in my 20s, it was dance. I even danced professionally for four years. So when I walked into the Western Australian Academy of Performing Arts' (WAPA) dance studio, a flood of happy memories rushed in. The wooden floor, the wall-length mirrors and the speakers hanging from the ceiling put me instantly at ease.

I was at WAPA to photograph Drew Holloway, a student of performance arts at the premiere institution. Given my personal tryst with dance, I knew I wanted to take a lot of experimental shots especially when you consider how line and symmetry play an important role in both dance and photography.

When I discussed my concepts with Drew, he seemed open to the idea of trying out something new.

Why do you dance?

I put this question forth to Drew minutes before the photo session.

"It helps me forget my worries and let's me be who I am at the same time."

...and then, as he moved, my camera danced along.

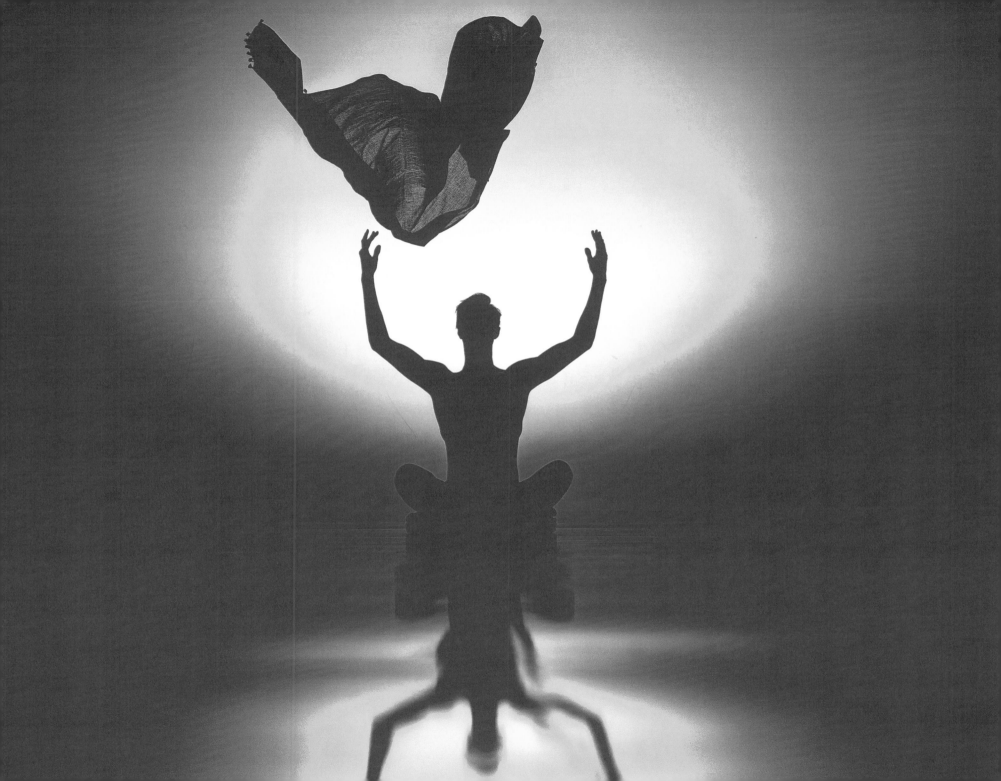

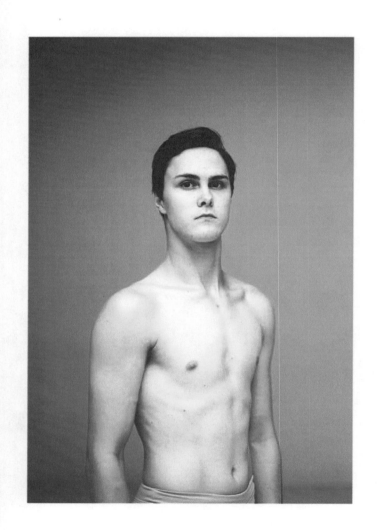

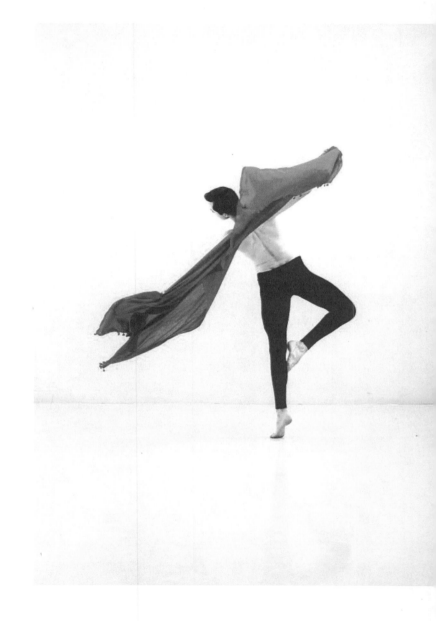

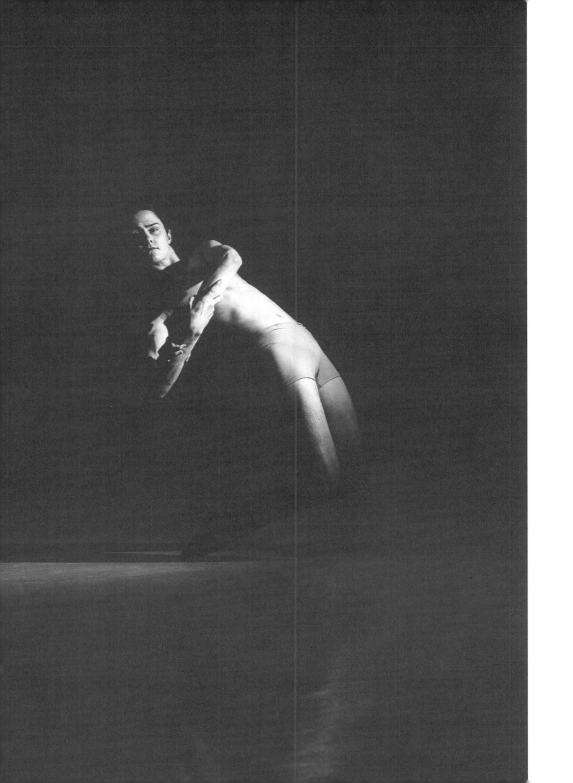
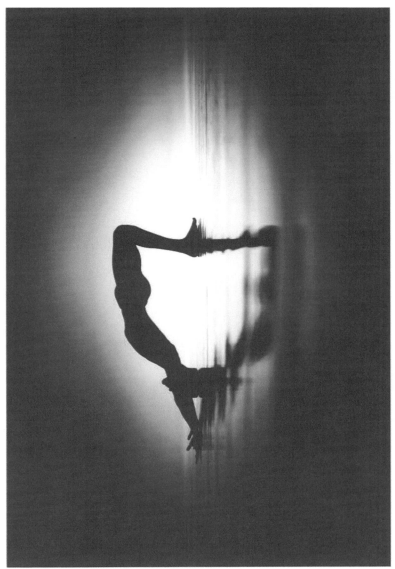

LOST IN
THE WOODS

Bonnie C Wheeler

During the time I lived in Perth, walking my two beautiful golden retrievers, Homer & Leia had become a daily ritual, sort of. On one of those walks, I chanced upon a lovely space of unexplored wilderness and I knew, seeing its expansiveness that I had to use it as a backdrop for at least one of my shoots.

Enter Bonnie C Wheeler.

A realtor by day, Bonnie is a multi-tasker who juggles her other roles as an actor, model, singer and mother to two cute dogs adeptly. When she approached me to do her portfolio photo shoot, it was the first time she was getting a professional set done. *"I've never done this before and this session will decide if I want to pursue modelling at all,"* she said to me in our initial interaction. While her statement made me nervous, I chose to focus on the task at hand and gave her simple advice: 'Be yourself'.

The photos you see are what happened at the scenic Maylands with Perth's skies playing along beautifully.

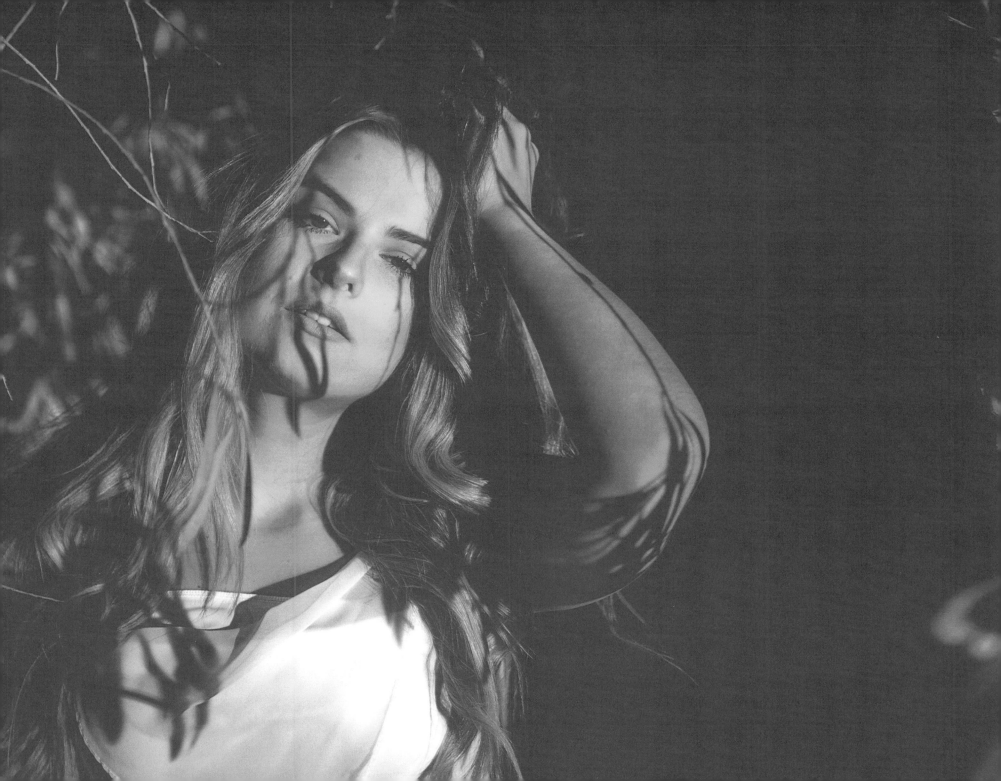

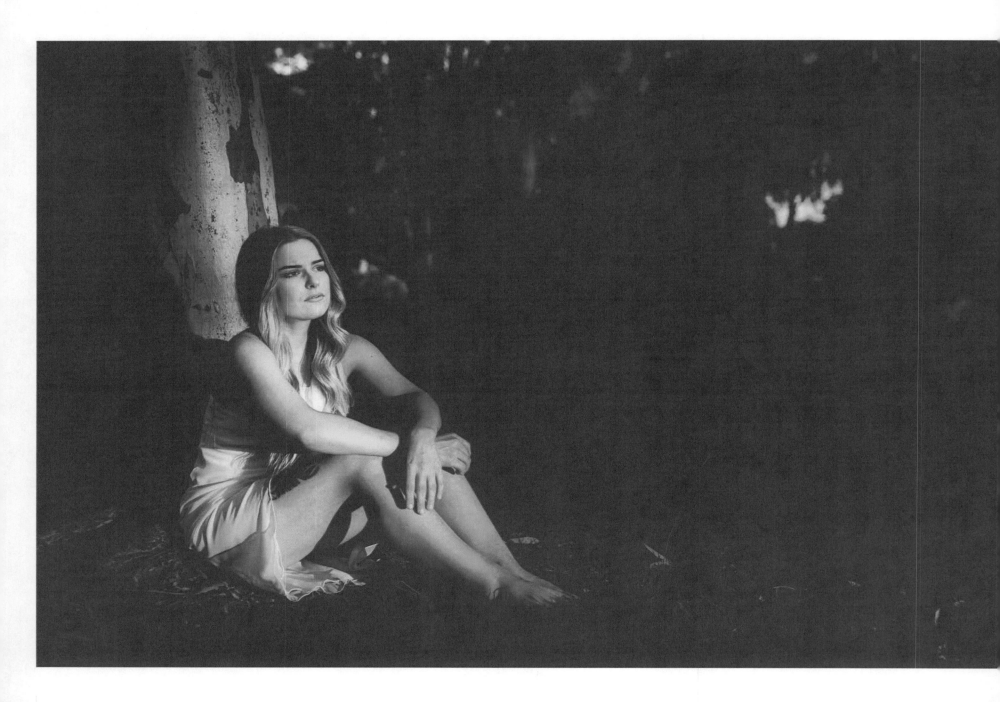

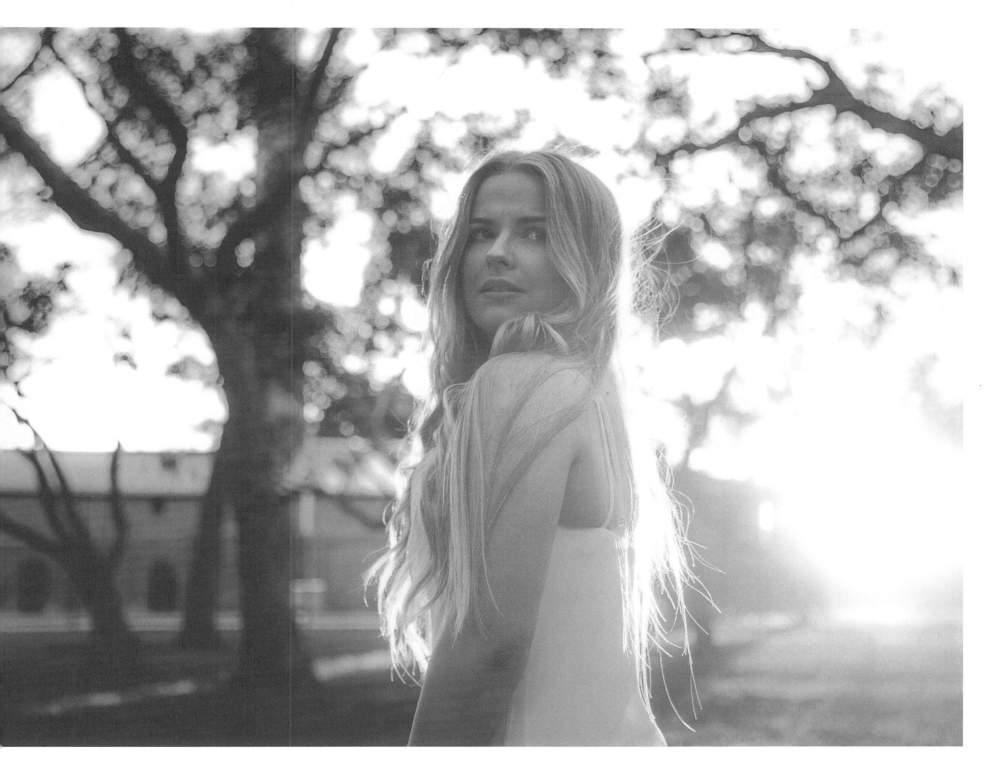

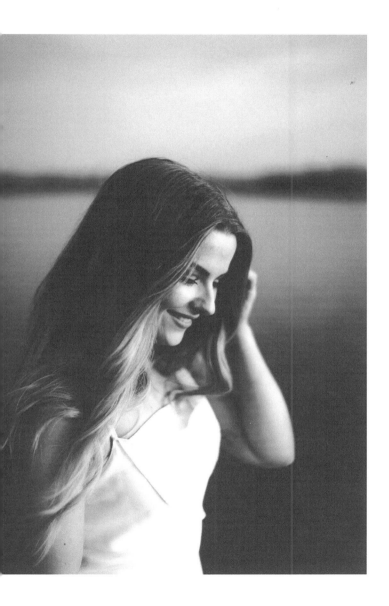
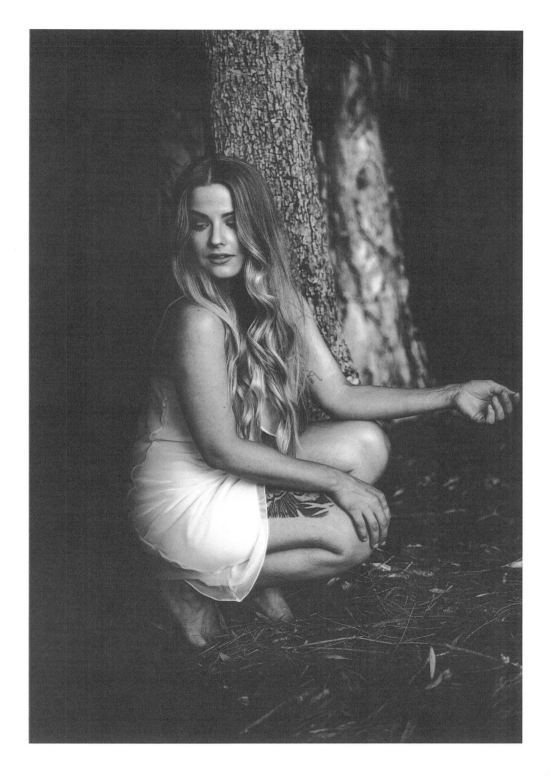

Ashish Puri

Have you heard the story of the Indian boy who lumbered through and made good in a foreign country? Ashish Puri is that boy who crafted his success story on the wings of his dreams.

Arriving in Australia from Dehradun in 1994 with a full-study scholarship at Curtin University, his first few months seemed surreal.

"When you come from a small town in India, have studied in a boarding school and then get out to see the real world, the feeling can be overwhelming, beautiful and scary at the same time."

During the early years, Ashish spent long hours working odd jobs to sustain his student life. When funds were short, he couch-surfed and survived on $2 burgers and pizzas. He did dishes, mowed lawns and also took to tutoring his classmates with the deal that he would be able to borrow their textbooks to study later. There was family land that his father was willing to sell to support his education but Ashish was adamant: *"Zameen nahi bechne dunga. I couldn't and wouldn't let my father sell his land."*

Today, Ashish's life is a picture of contentment. A commercial manager at the Pilbara Ports Authority, he is an adoring husband and father to two sons.

PS: I think the main reason why meeting Ashish meant so much to me was because I found parallels between his student life and my time in Perth as a photographer trying to survive 2020. A lot like his early student years, I was ready to schlep it out by doing any odd job that came my way. And as life threw curve balls at me, his story gave me the inspiration I needed to keep going.

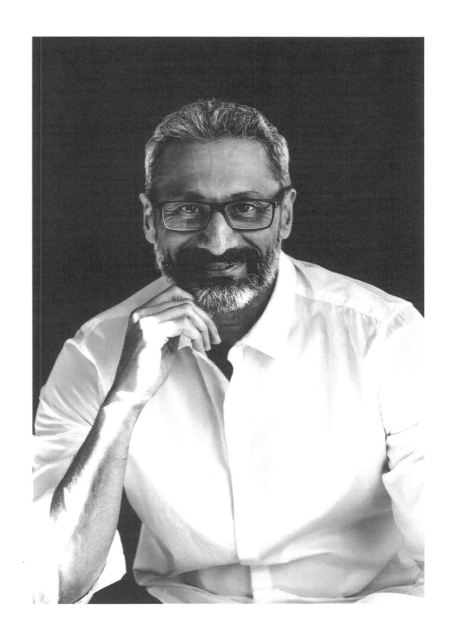

Nellie Marriott

—

Great grandma Nellie Marriott is one of Perth's oldest living humans. She turned 105-years-old in 2020. How many times in your life do you get to utter a statement like that? And more importantly, how many times do you get to meet a person who has lived for over a century and seen it all?

It was a sunny afternoon when I walked into great grandma Nellie's sweet little home. She was seated comfortably in a chair and the purple cardigan she'd worn added a bright splash to the scene. While I went about setting up my equipment, Nellie broke the ice with questions about my photography. That kinda helped loosen my nerves — I was after all photographing a living legend.

Born in 1915, Nellie is a mother to two, a grandmother to seven and a great grandmother to eight and is living through her second global pandemic.

"Please ask me to shut up if I am talking too much," Nellie made this remark with a glint in her eye while I was photographing her but what I'll remember about this assignment was how unhurried it was. Time, it seemed, was on pause. And as light shone on her, I took a close look at her hands and knew instantly that I had to capture them.

"Are you taking a photo of my legs?" she asked me gleefully. I told her that she had beautiful hands and wanted to capture them while they were resting. *"I have better-looking original teeth, if you ask me,"* she quipped.

The entire session with Nellie was an eye-opener for me. There was a lot more listening than just taking pictures — it taught me that there will be times when your subject will have a lot to say that cannot possibly be captured through the camera. It also made me realise the power of stories. Sometime during the shoot, I remember Nellie murmuring, *"I look forward to tomorrow…"*

Hope floated on a wrinkle and a smile.

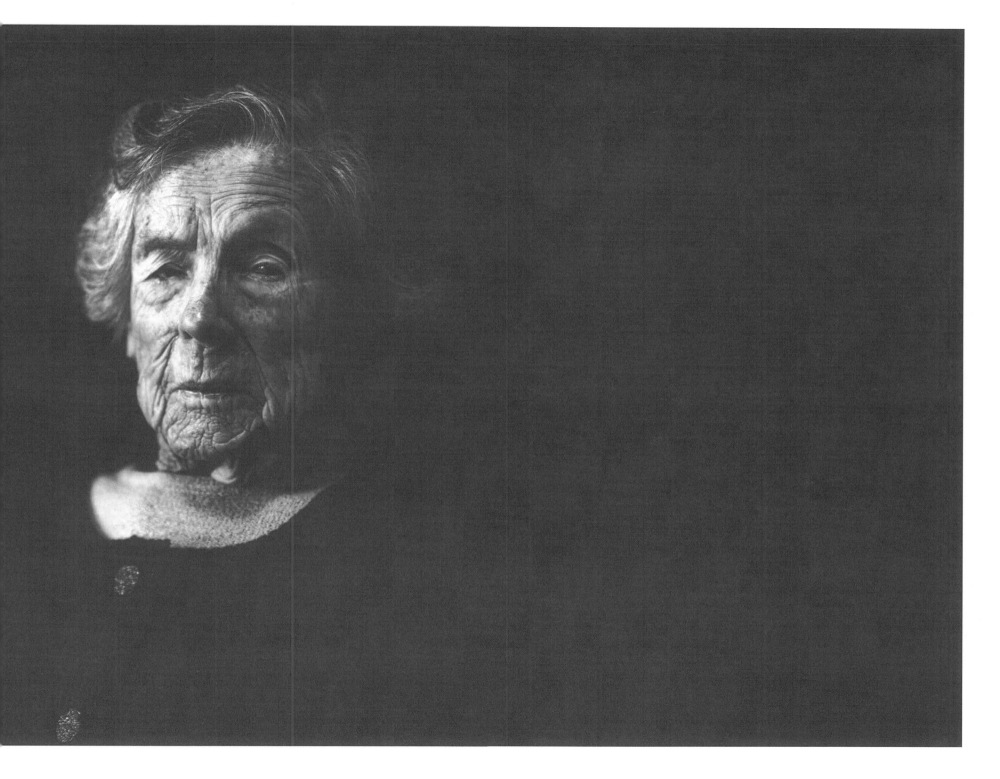

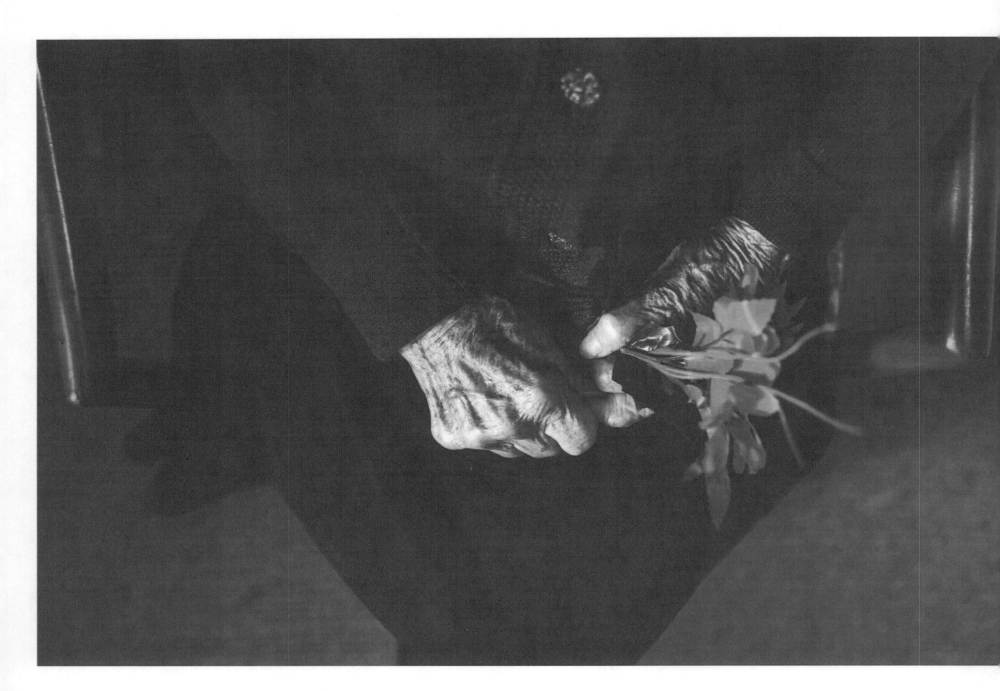

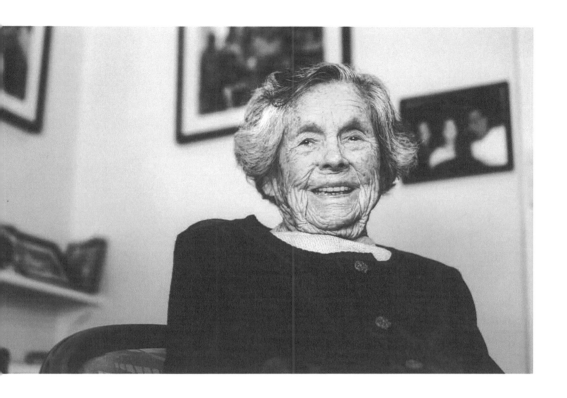

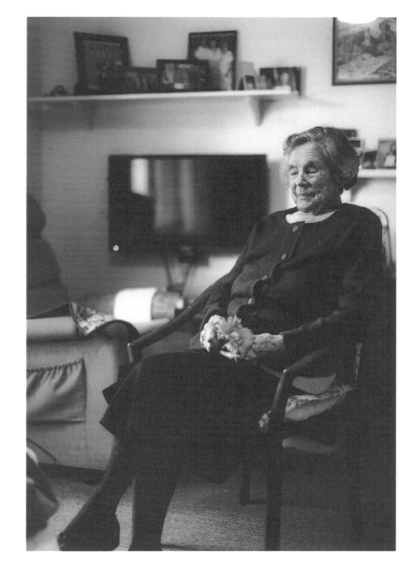

FREE SPIRIT

—

Safiya Karolia

———

One of my earliest underwater test shoots was with Safiya Karolia. For the both of us — Saf as model and me as photographer — the session wasn't without issues. For starters, the setting for the shoot was hardly favourable with the water in the pool that would serve as the backdrop for the series turning murky. It had rained the previous night and with the sun propped directly above our heads, we had a relatively short window of time to take the photos.

Saf is a renowned dancer, teacher and choreographer trained in a range of styles including jazz, contemporary and hip-hop. And this was going to be the first time she was doing an underwater shoot. The not-so-ideal situation had me feeling a bit underwhelmed, but that was until I said 'Action'. In a split second, I saw Saf transform from a poised person into a spirited dancer — the pool had become her stage and she performed fearlessly for my camera. The shutterbug in me went click-crazy.

That day, apart from the lovely conversation we had about dance, I also took back a learning: When a situation isn't going your way, step back, refocus, and just have fun in the moment.

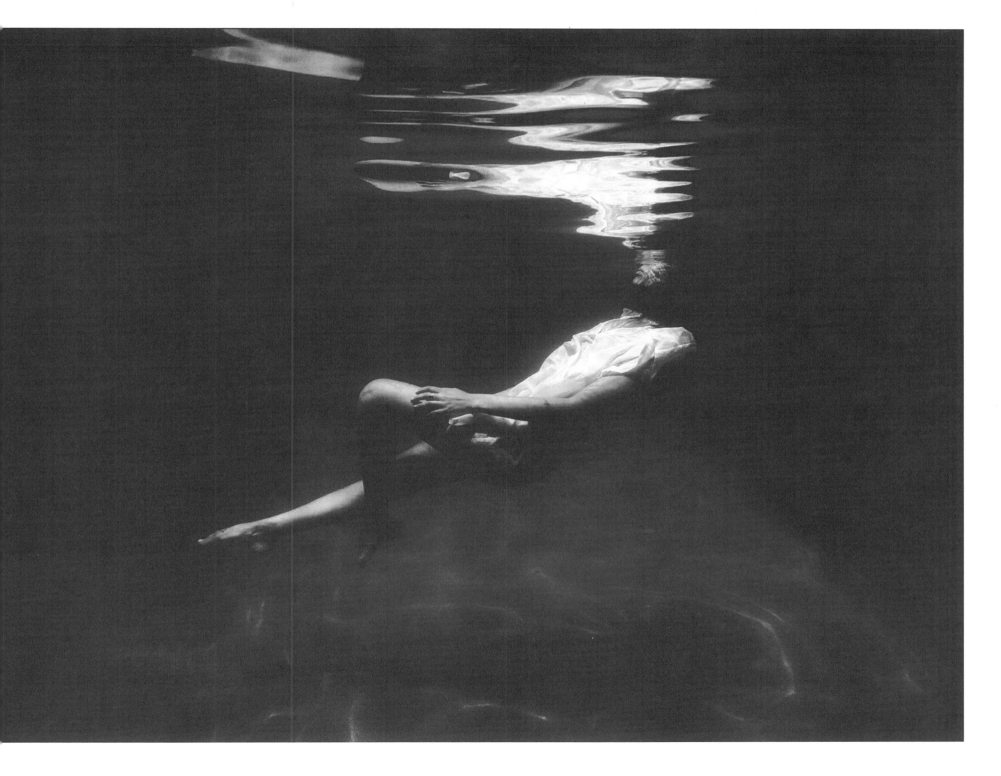

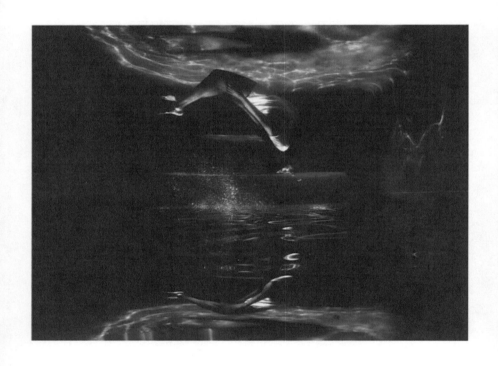
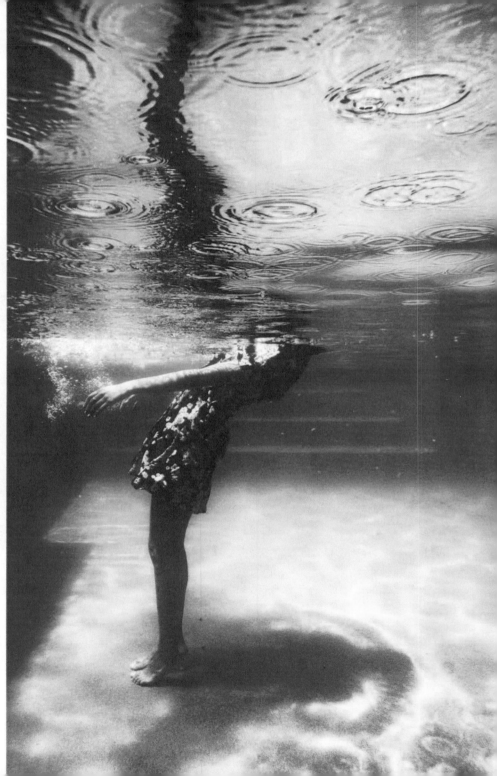

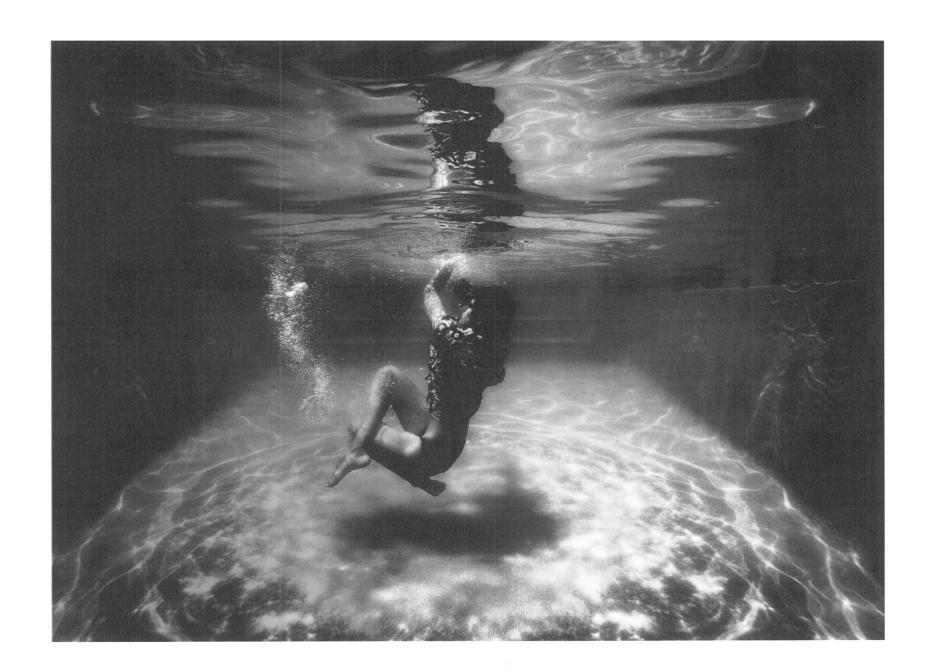

NEW
BEGINNINGS

—

Boudene Huckle

Living in Perth gave me the confidence to look at my work critically; it also helped me work on myself and push my abilities as a photographer. I remember talking to my friend, Bindiya Puri, about wanting to practice underwater photography. Bindiya turned out to be a gracious hostess who let me use her swimming pool to practice, but on one condition: That I'd eat whatever she'd cook for me. Confession: I think her food may have been the main perk in me trying underwater photography.

I ended up doing quite a few test shoots there, and then when I felt I was ready, I placed an ad offering my services as an underwater photographer. The ad received great response and I had many models reaching out to me.

Sixteen-year-old Boudene was one of the first models to book me for a session. Now, for a full-fledged underwater shoot, I shot this series on my GoPro. I was nervous because I didn't know what images would come off it, but Boudene turned out to be a great model and cheerleader. She was ready to keep going underwater until we got the perfect shot. *"Let's try that once more,"* was her mantra for the day.

The photos you see here are the result of Boudene's indefatigability and me just going with my gut - hah!

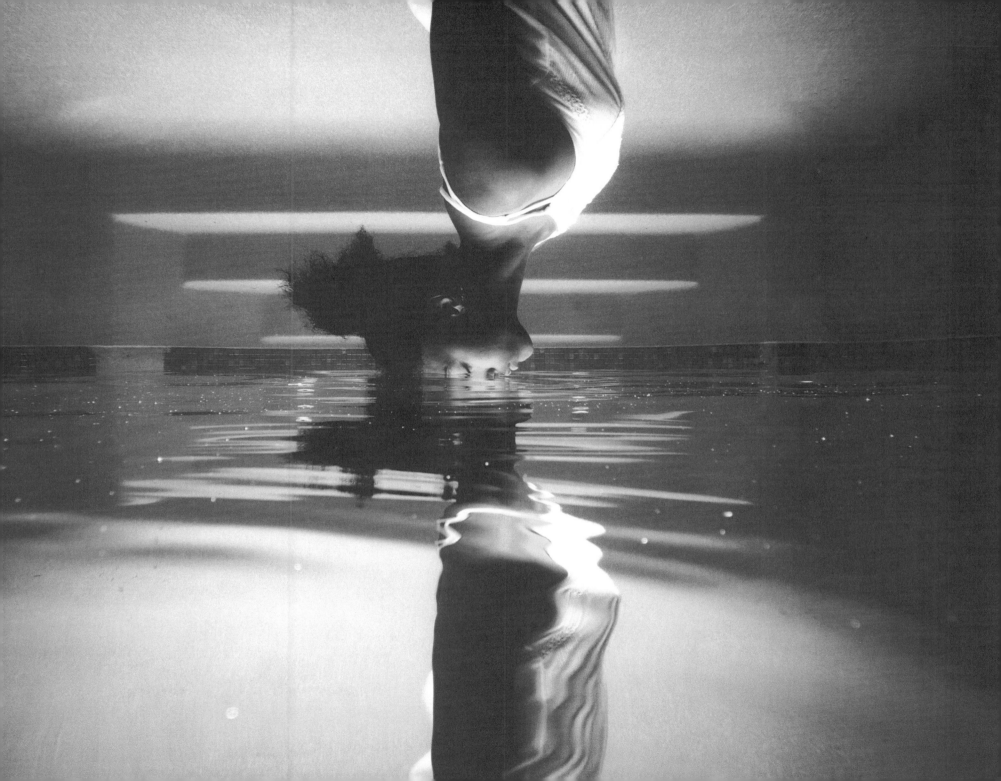

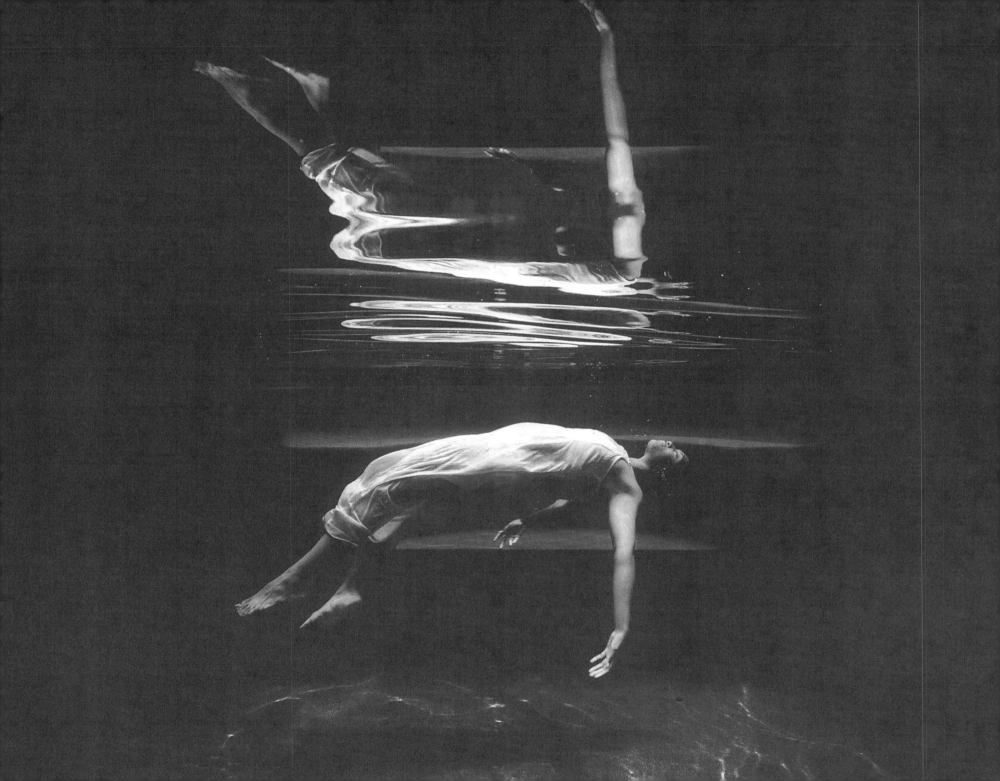

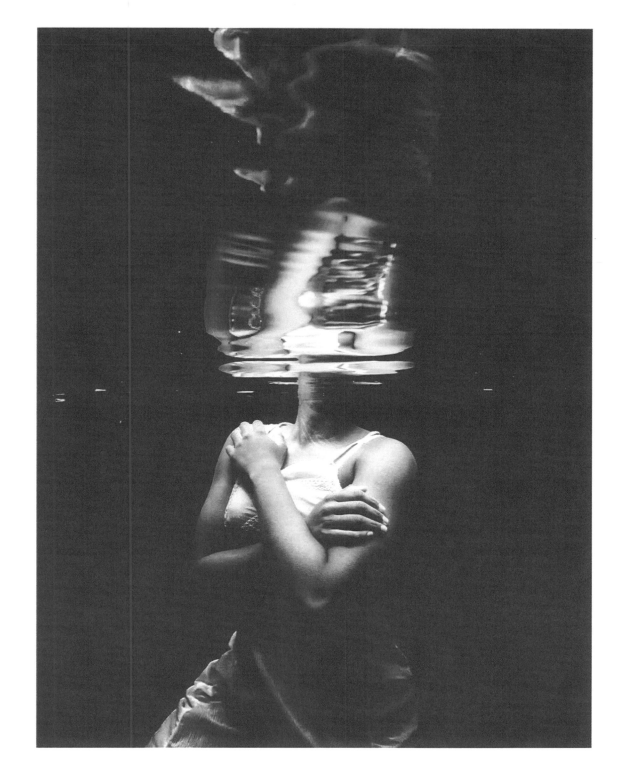

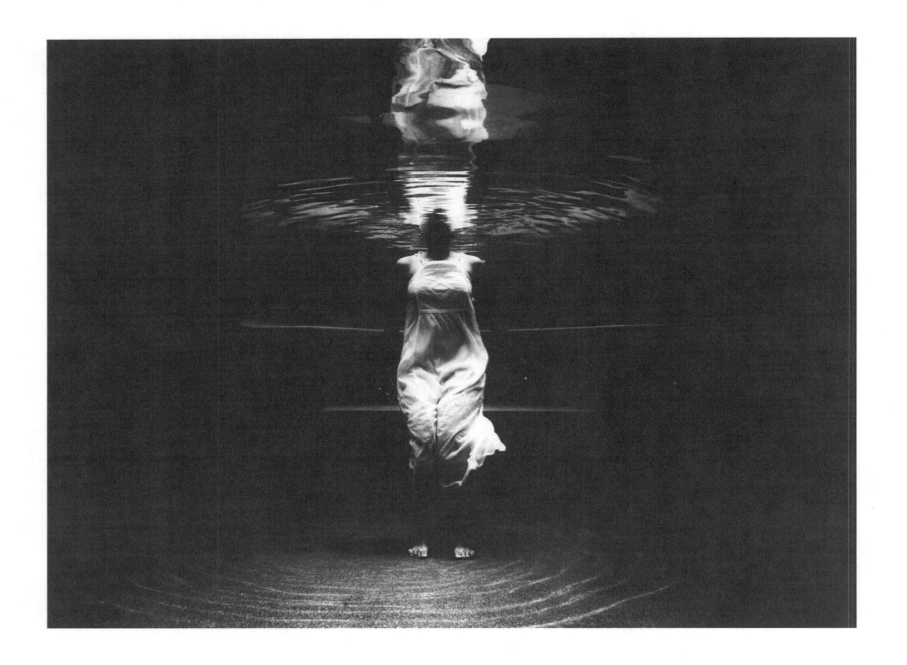

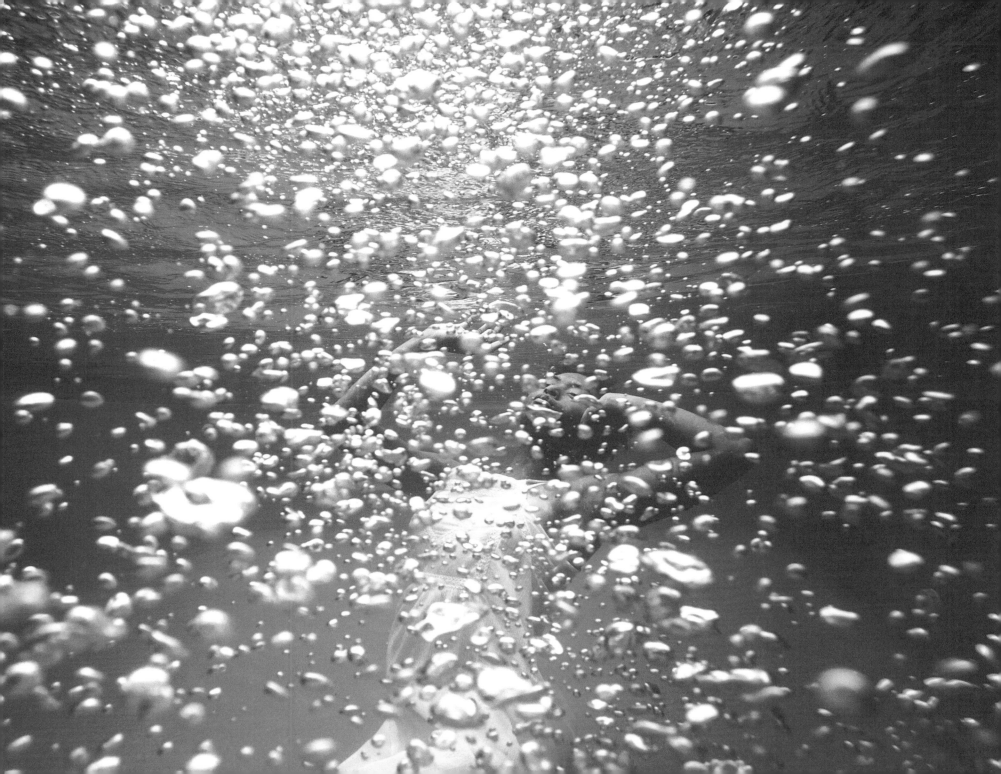

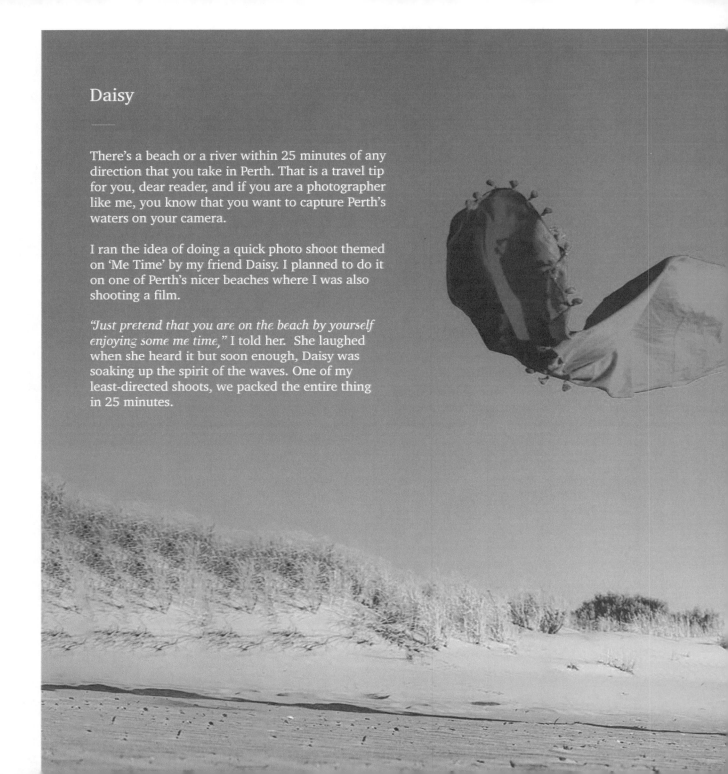

Daisy

There's a beach or a river within 25 minutes of any direction that you take in Perth. That is a travel tip for you, dear reader, and if you are a photographer like me, you know that you want to capture Perth's waters on your camera.

I ran the idea of doing a quick photo shoot themed on 'Me Time' by my friend Daisy. I planned to do it on one of Perth's nicer beaches where I was also shooting a film.

"Just pretend that you are on the beach by yourself enjoying some me time," I told her. She laughed when she heard it but soon enough, Daisy was soaking up the spirit of the waves. One of my least-directed shoots, we packed the entire thing in 25 minutes.

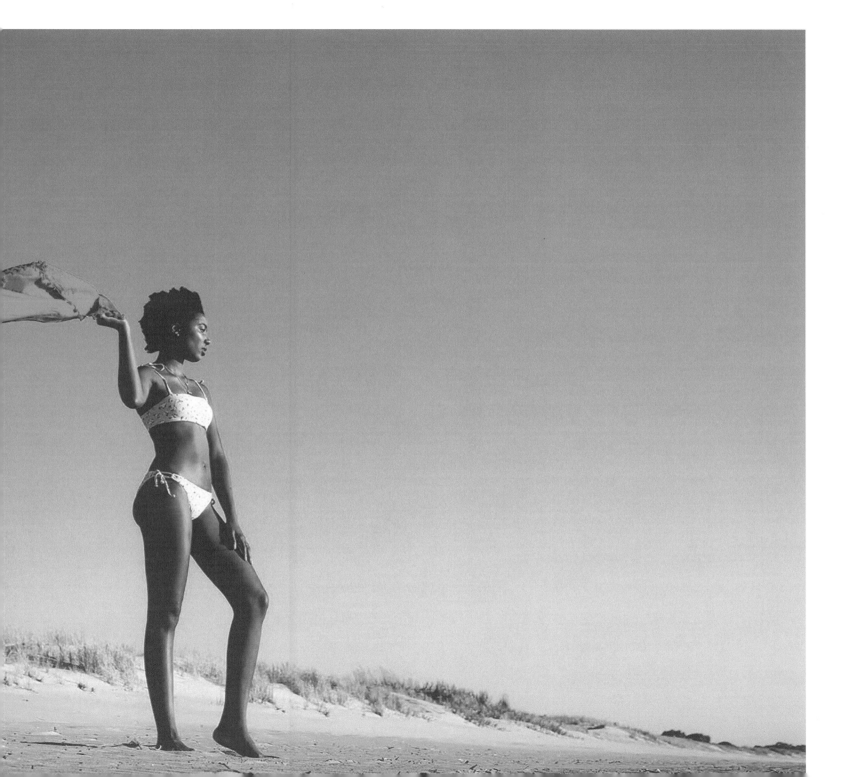

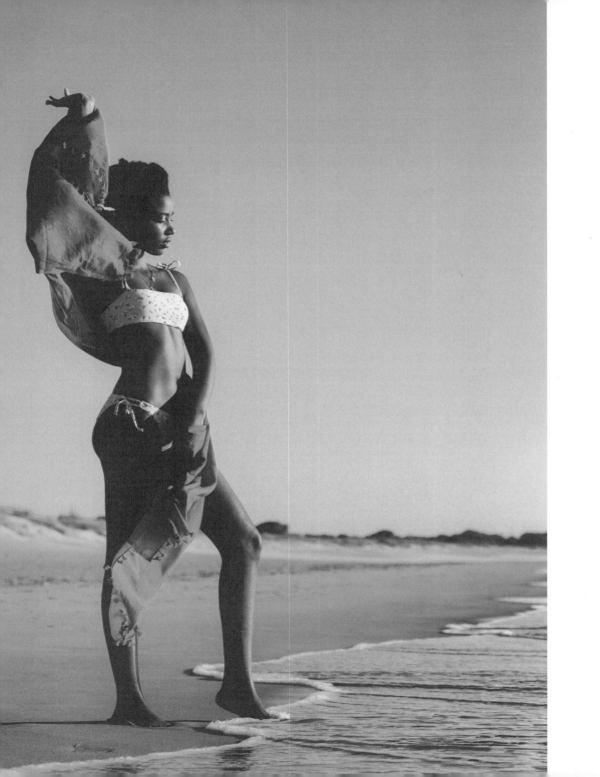
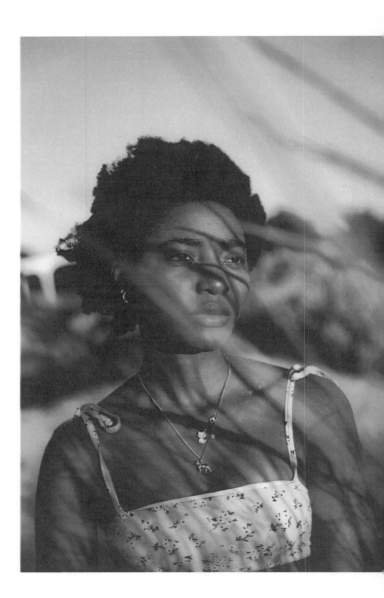

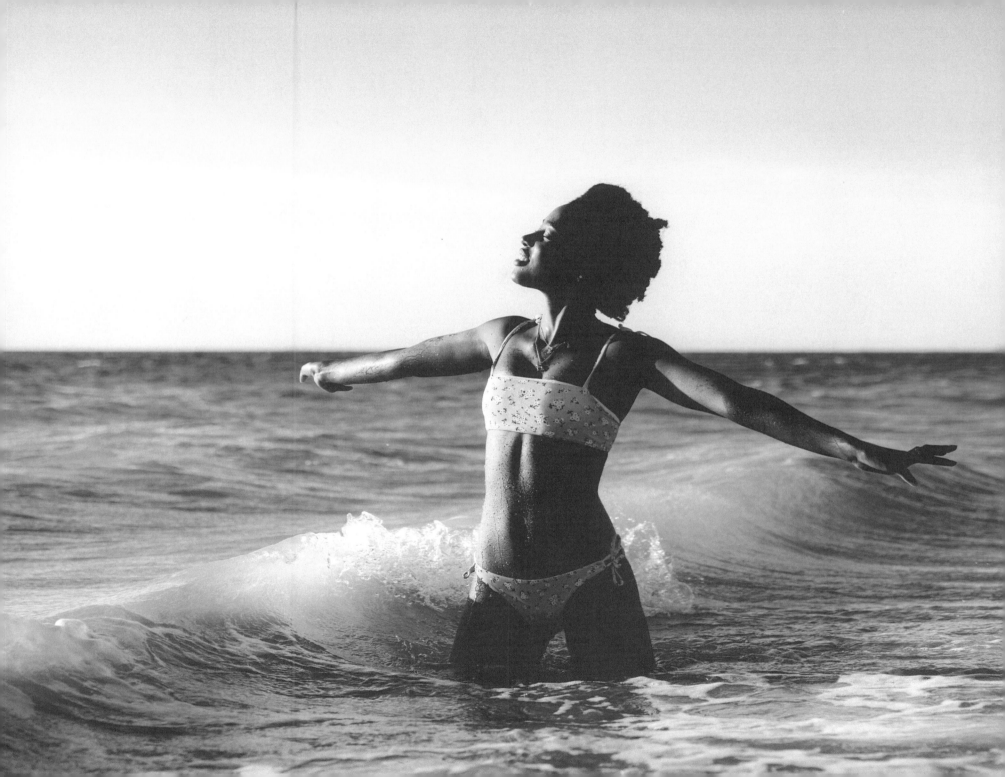

TWINNING

Kiana Lee & Tyler Lee

When I'd arrived in Perth at the beginning of 2020, the year ahead looked good. I had already planned a detailed travel itinerary for the entire year: Japan in March, Maldives and Sri Lanka in April, Singapore in May for my birthday, Bali in June, a short break home in Bangalore before heading out for a south India tour through July and August, UAE in September, America in October and November, and Perth again in December to finish the year in style. In retrospect, it was quite an ambitious plan which didn't go anywhere.

While I was busy working on this exhaustive travel plan, a photographer friend one day asked me if I'd like to accompany him for a shoot. I agreed, mainly because the location of the shoot was about an hour and a half away from Perth by road. When we got to the location, we realised that it was a farm where they trained horses. We were welcomed by Michelle Murphy, a talent scout and manager of her twin daughters, Kiana and Tyler Lee. What caught my eye was how confident and fashionably aware the girls were.

The scenic location, my first close interaction with horses and these talented teenagers ensured that this photo session was one for the books.

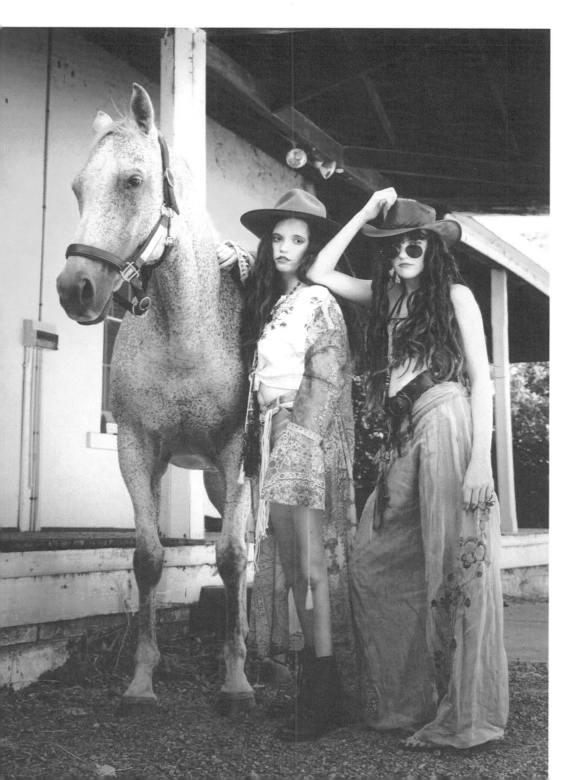

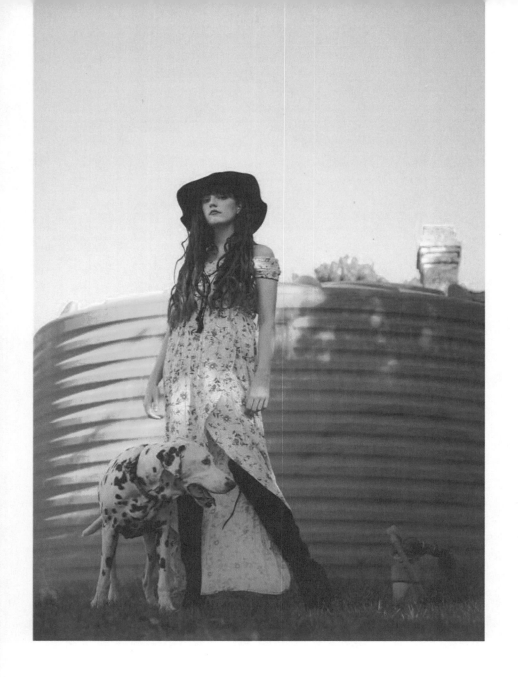

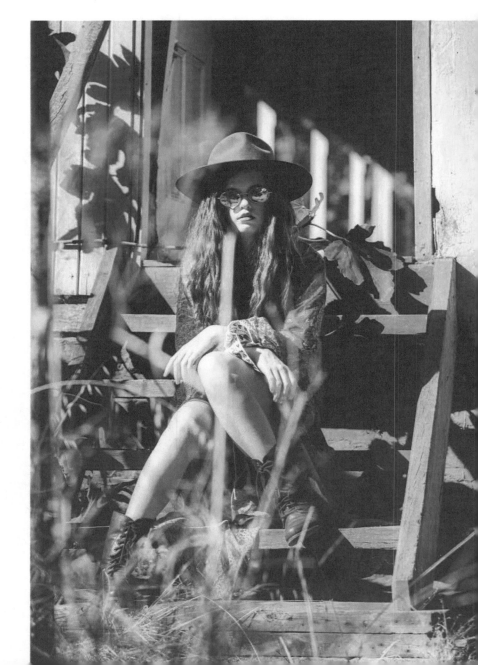

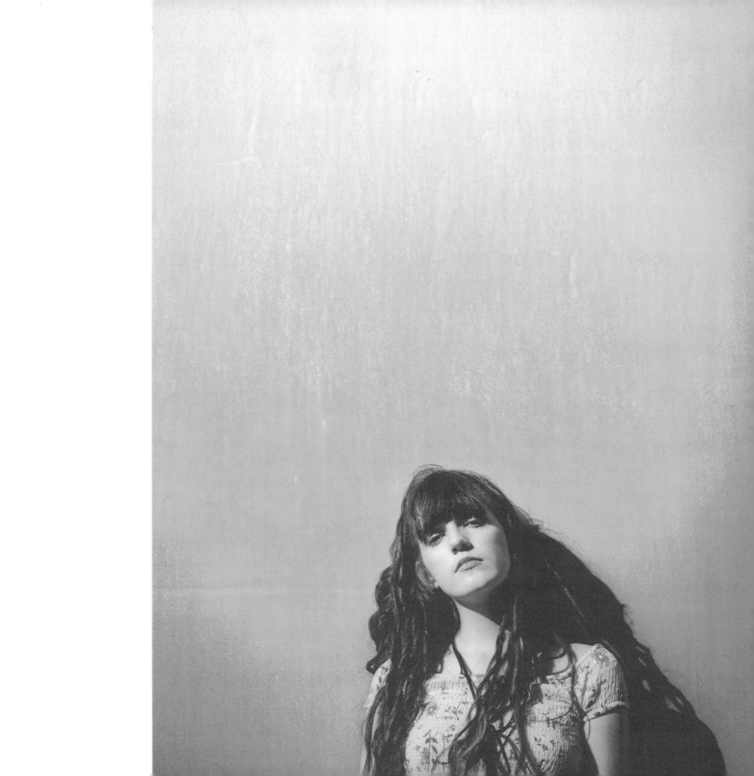

INTERLUDE

When you really look, every scene in front of you is a photograph waiting to happen. During the weekends, work, photo shoots, or any time of the day or night, I'd sometimes take off on my own to ruminate on life, love, and at times, less profound things. In between my musings, I'd find myself stopping to take pictures of things that caught my eye, on my phone.

Come, let's take a slight detour…

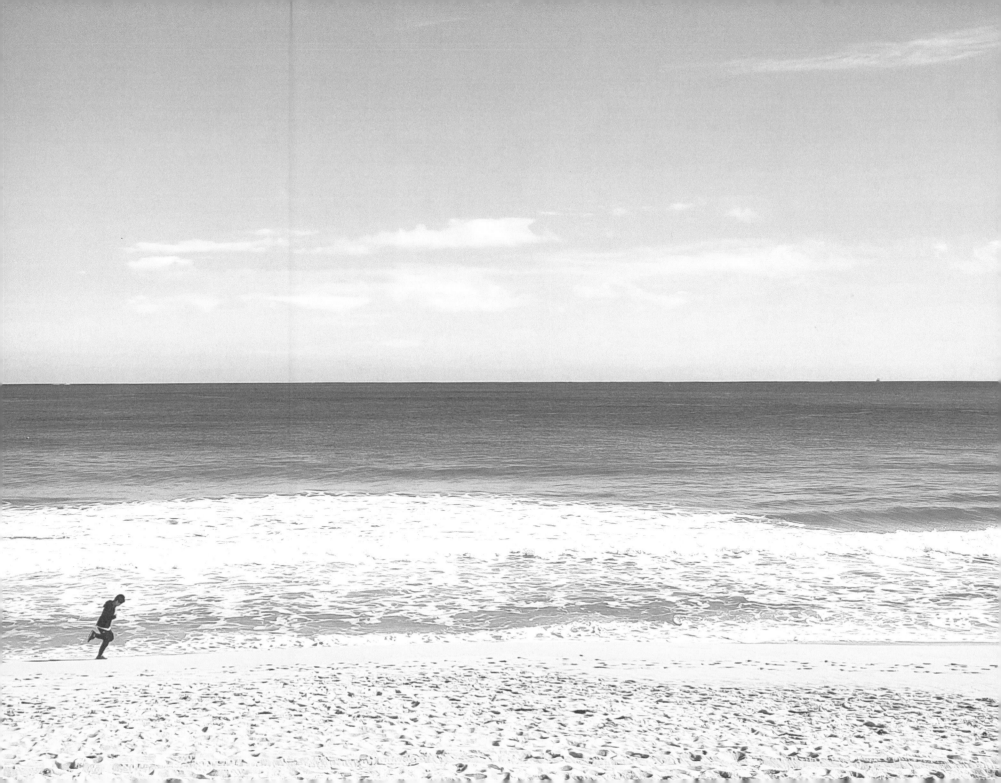

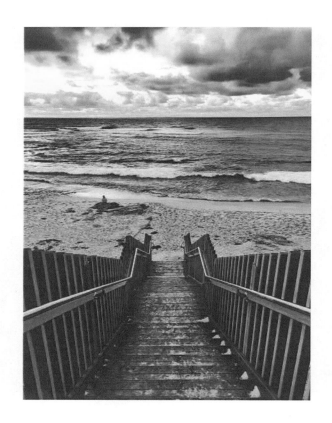

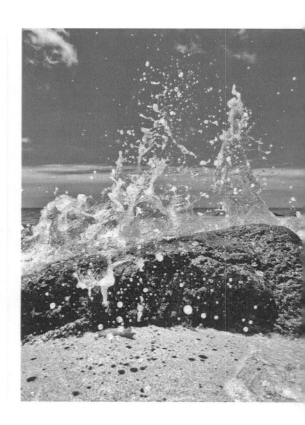

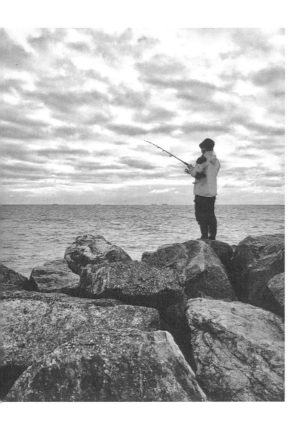 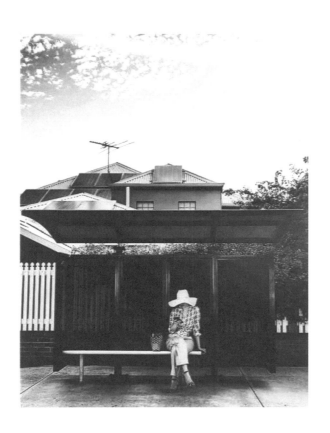

MADE
IN AFRICA
—

Astrid Tshidibu

—

"I am planning to go to Congo! It is important for me to travel back to my native land because I want to learn all that I can about my roots. Above all, I want to meet my mam."

I first met Astrid Tshidibu in Perth in 2018 when I was doing a street fashion shoot with another model. Astrid was curious to know what we were up to. When I told her that we were doing 'a simple street-styled fashion shoot' she jumped at the chance and asked me if she could direct the model. I agreed and that is how our friendship began.

When we met again, Astrid and I were excited with the idea of doing a photo shoot together. We may have exchanged a 100 ideas between us until we zeroed in on one that resonated the most with us. We chose to call it Made in Africa because Astrid wanted the essence of her motherland to come through the photos — through the colours, clothes and makeup. She had an evocative backstory to go with it all.

Born in a small African town called Kananga, Astrid's family had moved to Kinshasa and later, Europe when she was still a kid. Growing up in Europe and Australia, there is a part of Astrid that yearns to reconnect to her place of origin. Then there is the fact that she wants to meet her birth mother. This was, as she confided to me, a revelation that she'd got to know only last year.

"My grandmother did not welcome my mam as she felt she was not good enough for my father. My father ended up marrying my stepmother. Both of them raised me and took good care of me, but they never told me about my biological mother. It was a shock and I felt betrayed when I got to know about it. Now, learning about my mother has given me the courage to go back home and find the part of the puzzle that is missing in me."

I remember being fascinated by the way Astrid went about deftly wrapping the colourful fabrics she'd bought for the session into different dresses. *"I am wearing the material in the Congolese Liputa style,"* she explained to me. She finished the entire look by wearing the blue headgear (Kitambala in Congolese). How regal she looked.

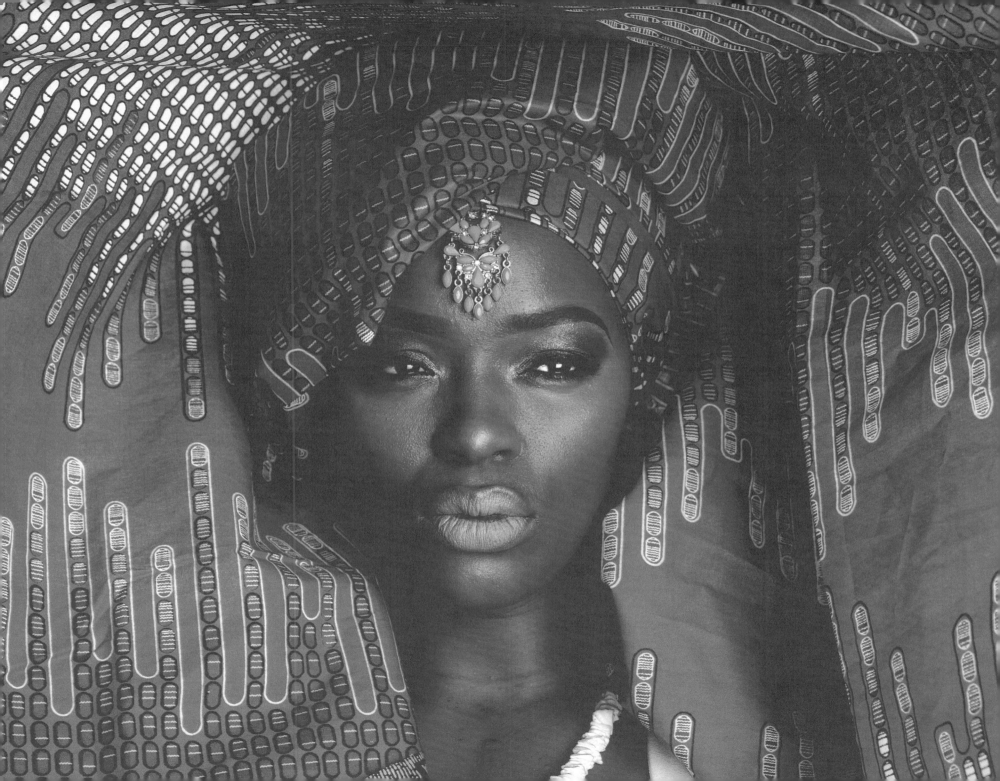

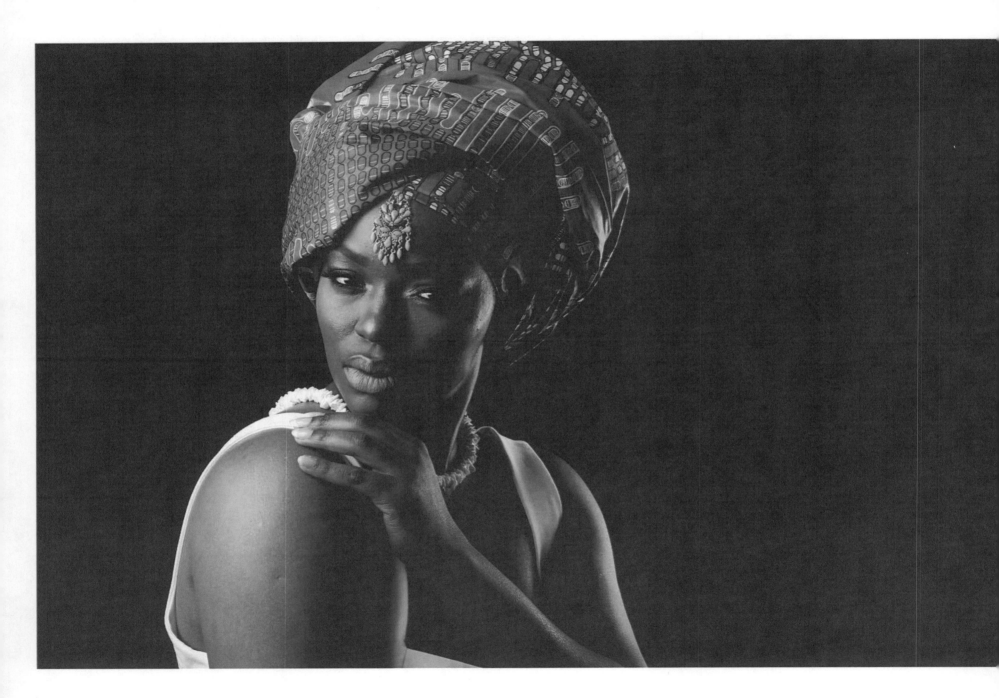

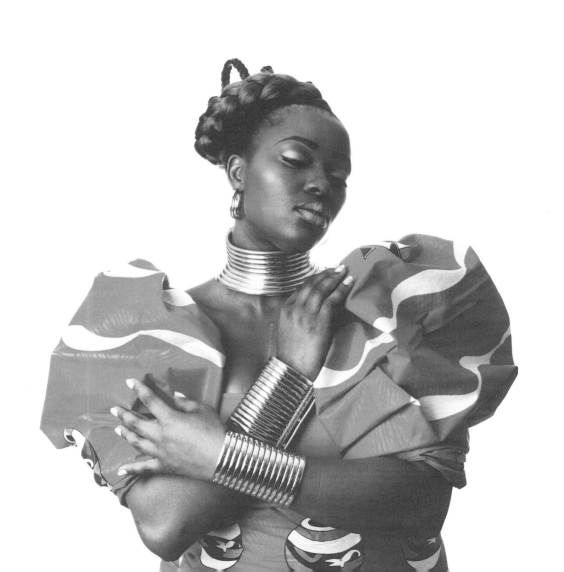

COME AS
YOU ARE

—

Sophie Whitalker

—

"I want to gift these to my partner and I'm excited about it."

Boudoir photography is quite unlike any other genre of photography. The act of letting an unknown individual into your space and baring your skin with the trust that they will not cross that invisible boundary of intimacy and professionalism… well, that is a vulnerable place both the model and the photographer occupy.

Now, to get on with this story, Sophie Whitalker walked into my life one day deciding that she wanted to get her pictures taken by me. A professional model and a photographer's assistant herself, Sophie wanted to do this series — which was going to be a gift to her partner — to explore the 'sexy' in her. I decided to go for imagery that would be dramatic and sensual. Just minutes before the shoot, I asked Sophie how she would define sexy?

"Sexy lies in the personality and the mind. A sexy mind leaves a lasting impression far longer than a sexy body," she answered.

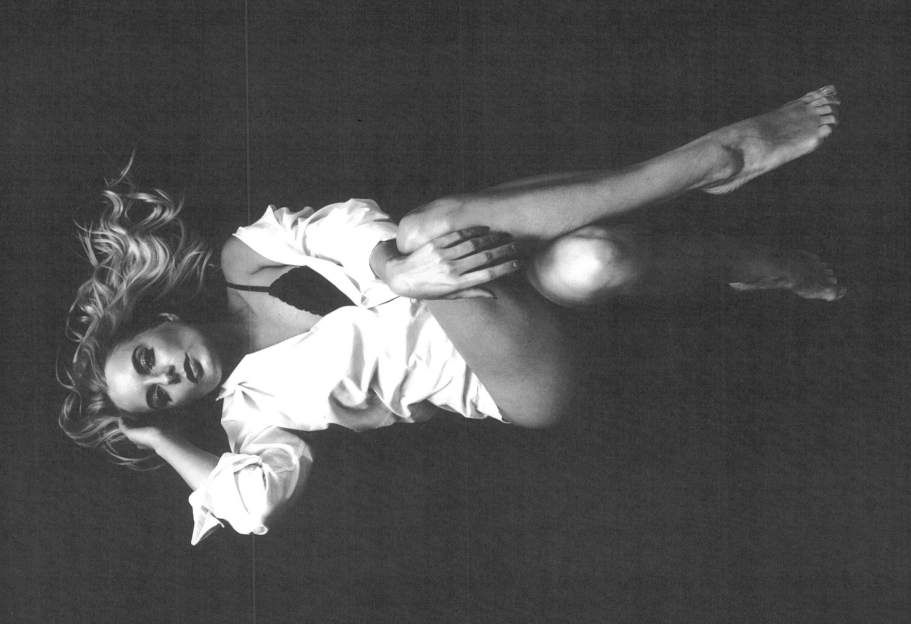

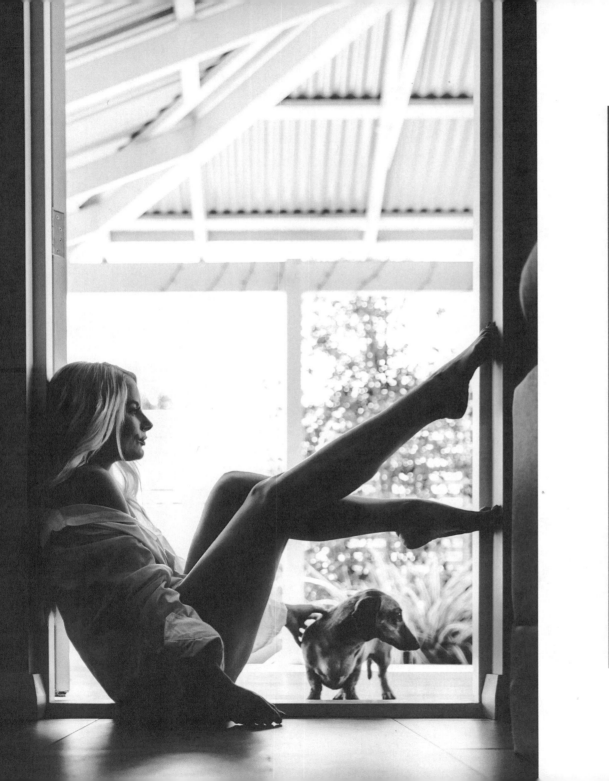
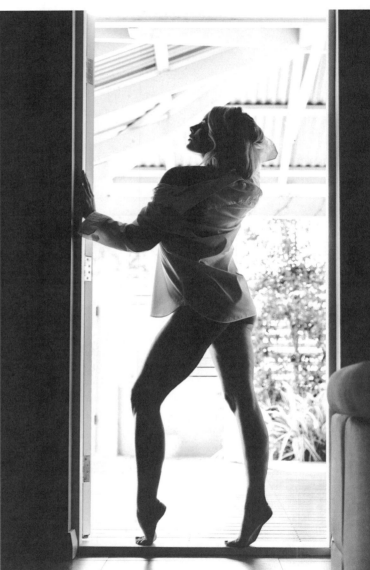

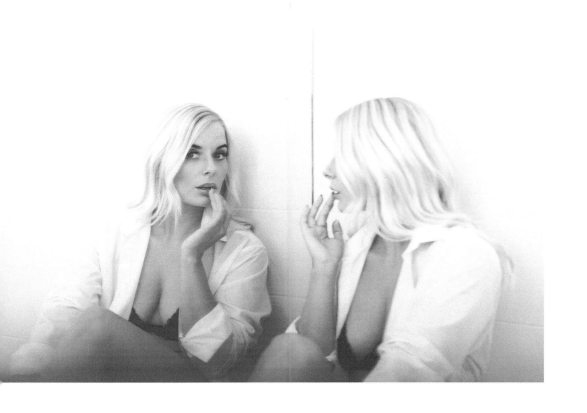

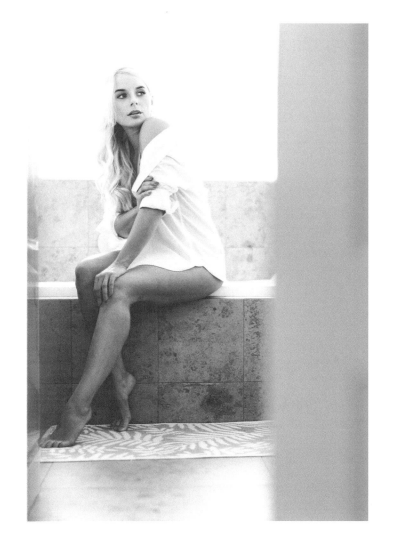

Kelly Read

"I must tell you that I am the worst person in front of the camera. I have never been able to get a single decent picture of mine for the longest time."
My first conversation with Kelly Read began with these lines.

My first meeting with Kelly had happened a few days earlier at an office party that was being held at The Crown Hotel where she was the resident musician. Kelly is an incredible singer and that evening, I remember being enthralled by her voice as she sang an Adele number. I took a photo of hers as she performed, on my phone, and when I showed it to her she liked it well enough to agree to do a professional set with me. She'd be one of the last people I'd photograph before I returned to India.

"I have a very pretty sister. Maybe that is why I have always felt like I won't be able to make pretty pictures of myself."

A former contestant in the Australian reality talent show, The Voice, Kelly is quite the celebrity in Perth. So to hear these self-deprecatory words from a person as talented as her sounded contradictory. It also struck me how people irrespective of their status in society felt unnerved by the camera — possibly because they fear that their real persona would come out in the pictures.

I managed to calm Kelly's nerves and have a fun photo shoot. While I knew we'd done a good job, I think I'd never smiled as wide as when Kelly saw her photos and said, *"I have never seen so many photos of myself that I actually liked!"*

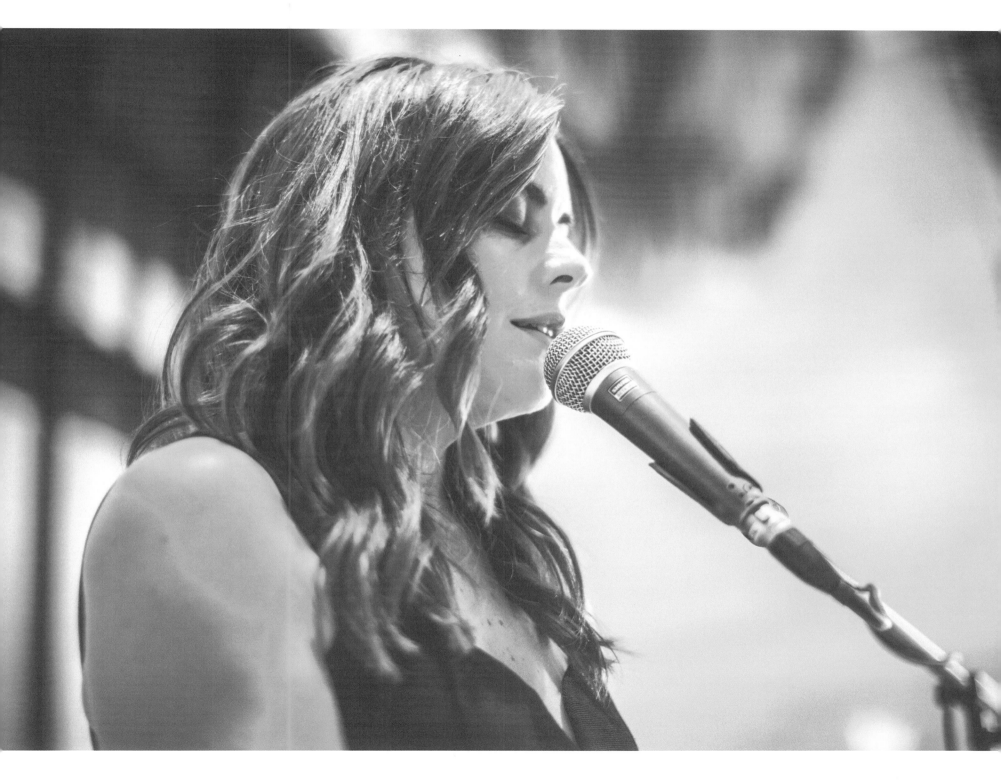

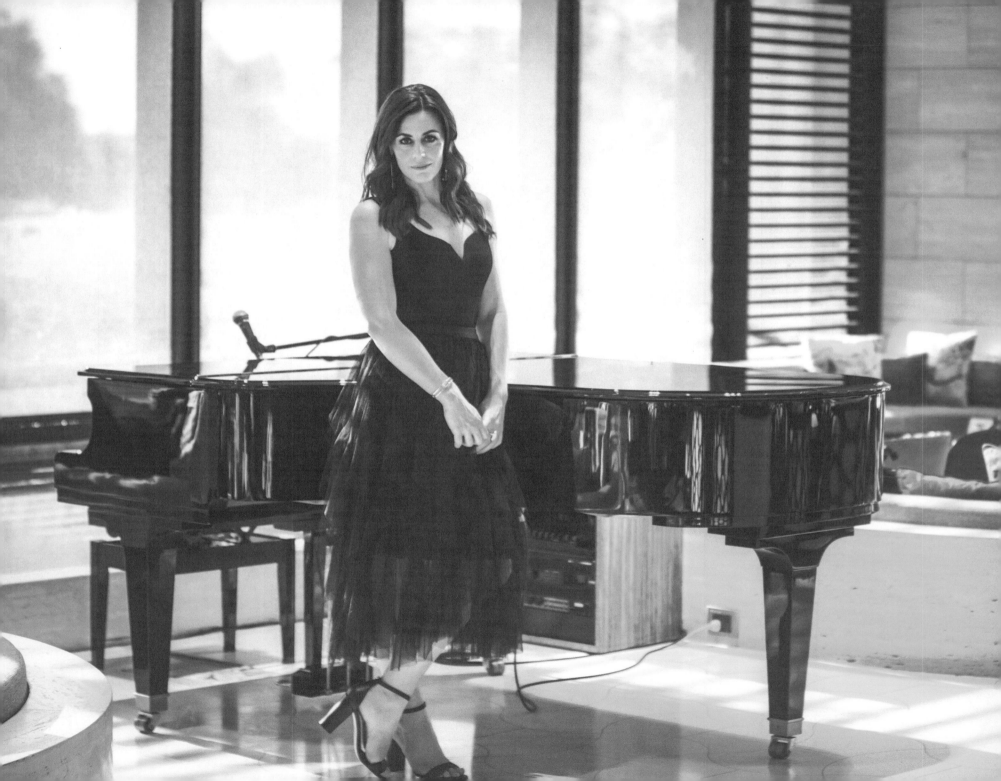

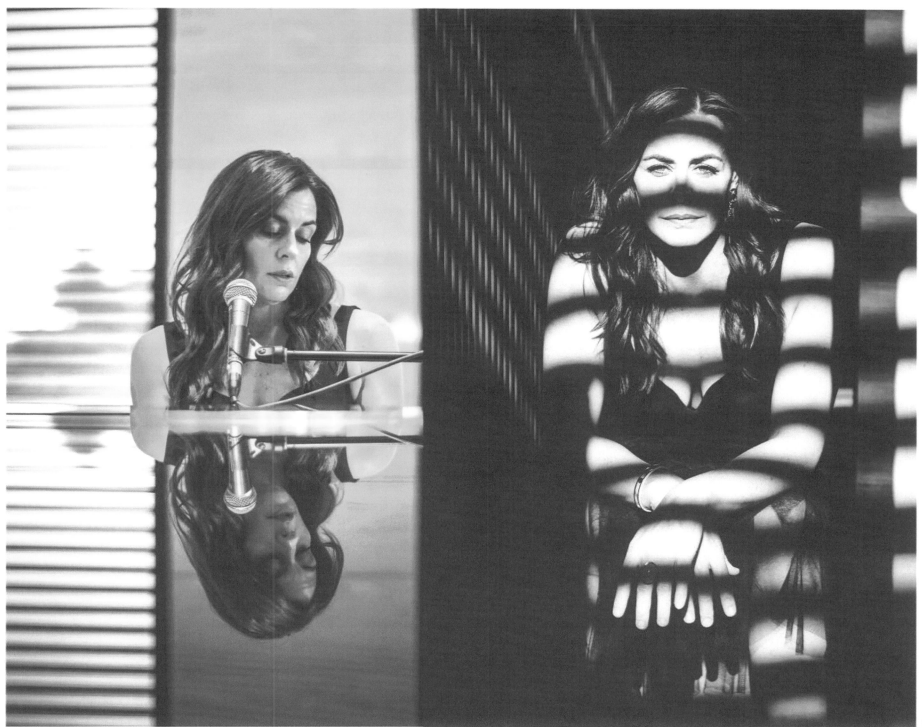

ELEMENTS

Taylee McIntyre

———

'Coz she's a born leader.

Throughout our initial conversations, I had got the impression that Taylee McIntyre was a fitness model, until on the day of the shoot she revealed that she was a firefighter. As an Indian kid who grew up watching Hollywood movies, I knew how awe-inspiring the job of a firefighter was. Know what the entire irony of my photo shoot with Taylee was?

I was shooting her under water.

We chose for her to wear a flowy dress in flaming red for the shoot. How perfectly apt, I couldn't help thinking. Right before we began the shoot, I asked Taylee how her life in 2020 had been.

"2020 has been an unexpected year. It has been an extremely busy year for me yet there's a strange quietness to the whole thing. I am about to head my own sub-division and I have also just started another career. Over all, my days between holding three jobs and being a stepmom have been crazy but I probably wouldn't want it any other way. That said, leading a hectic life also means that I get to focus my energies on photo shoots and enjoying my downtime when I can."

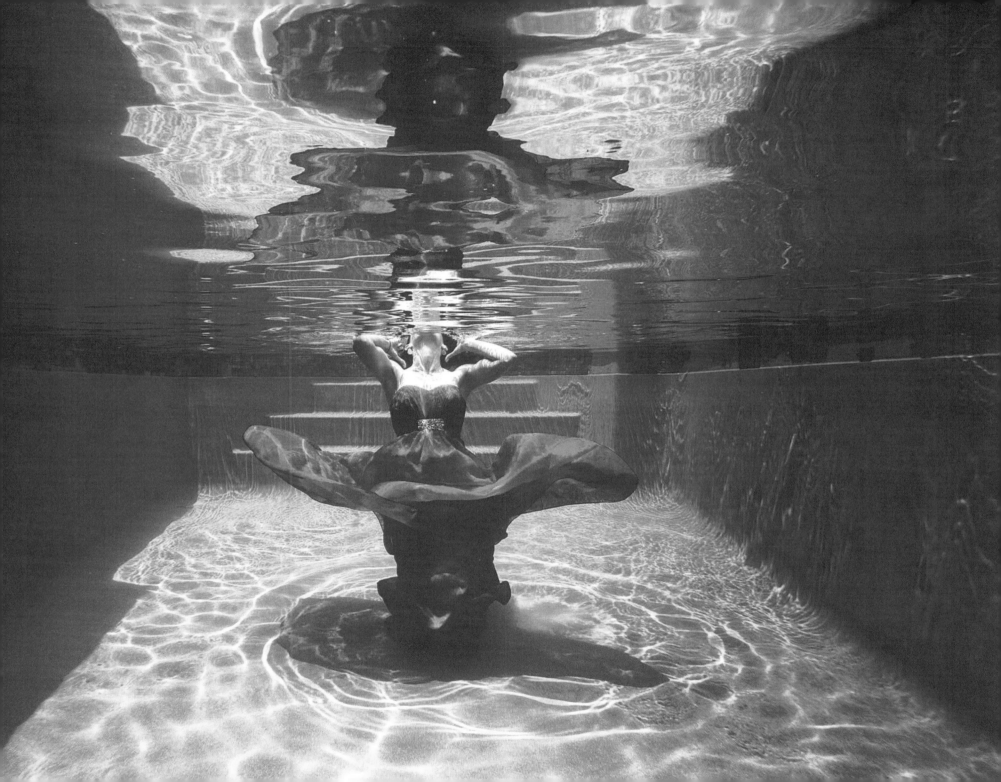

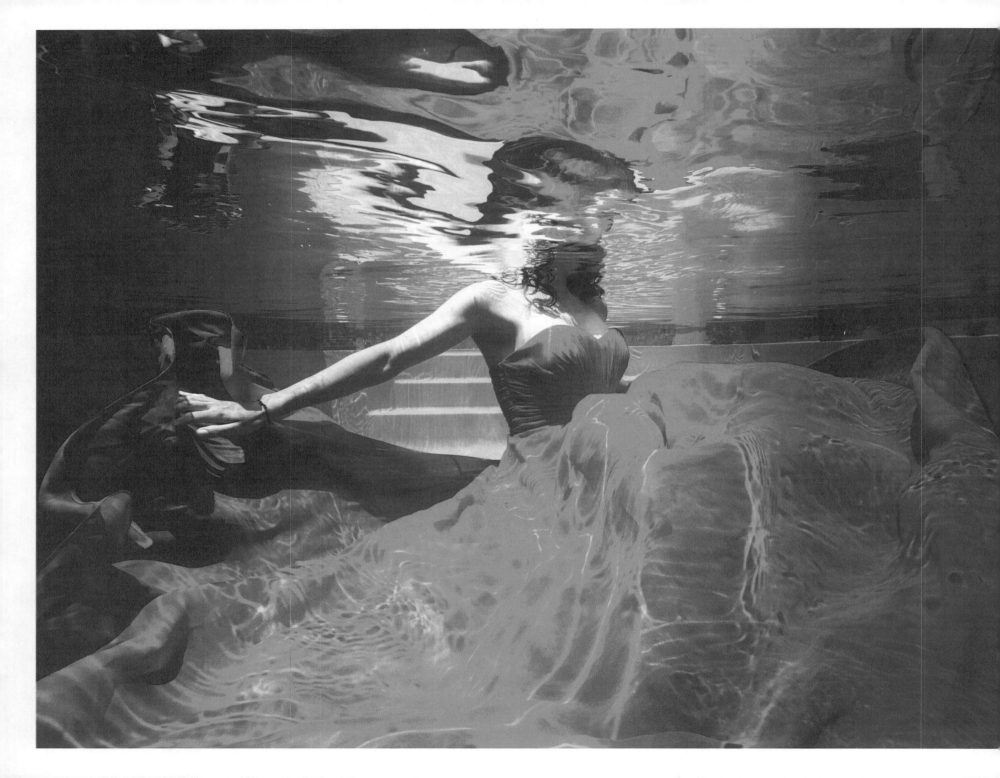

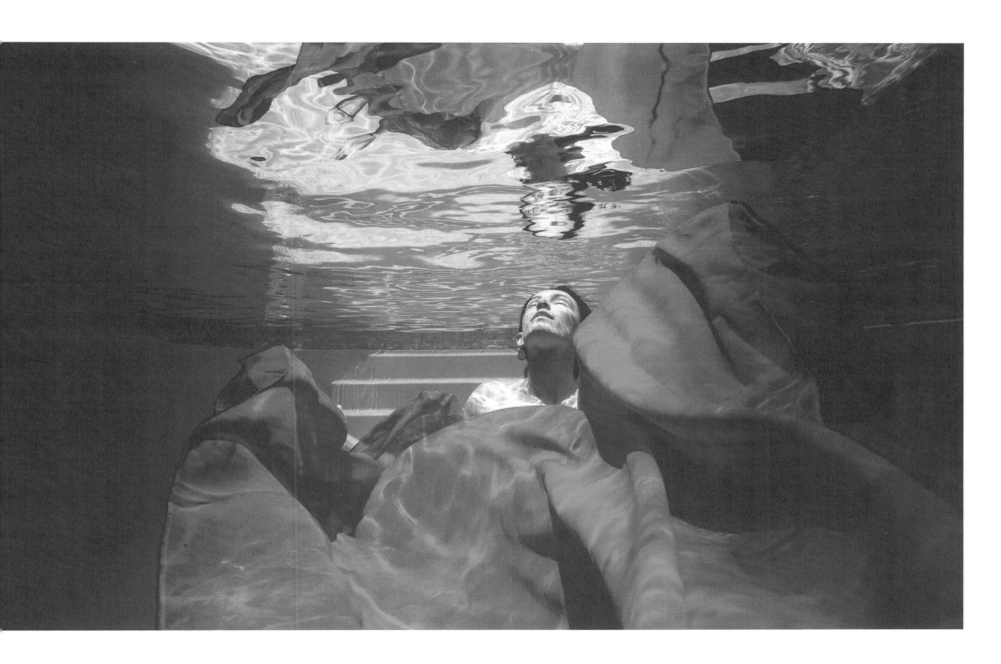

A HAPPY
ASSORTMENT

My job as school photographer with 3P Photography was a full-time gig but I also spent a good many hours, mainly over the weekends, doing independent assignments. In addition to fashion and corporate lifestyle shoots, I also got to photograph families, pets, babies, and couples in love.

Maya & Riya

Dalia - Yaqub

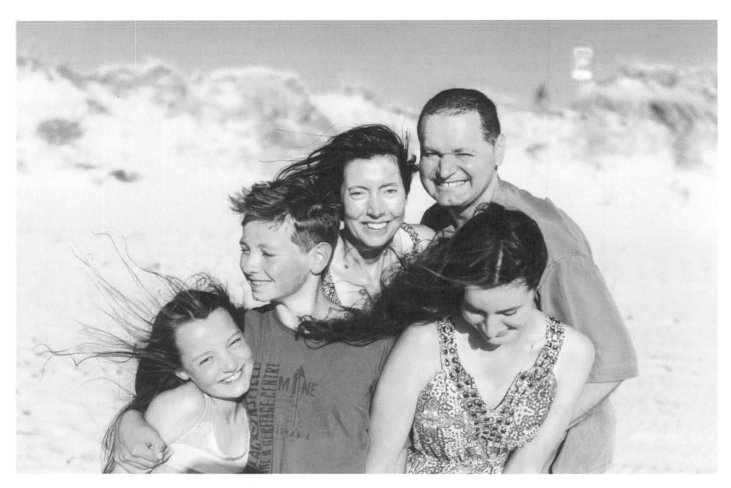

The Piccinini Family

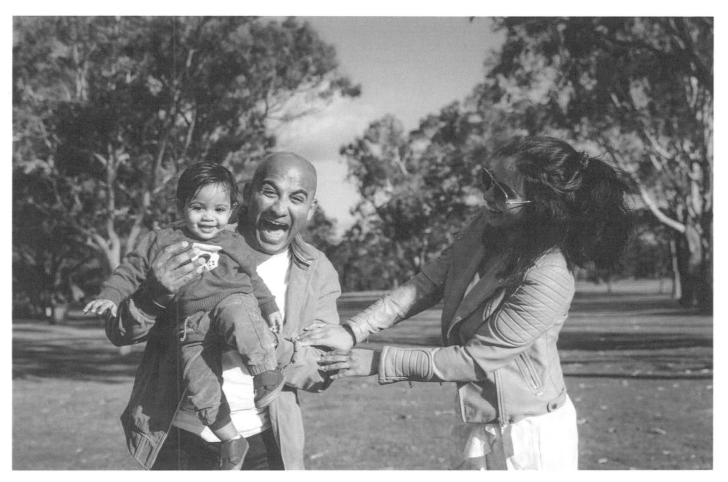

Brian & Family

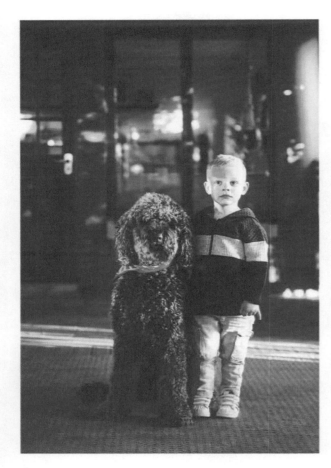

Ted & Sir Walter
the Doggie

Jessicca Wilkinson
& Ted

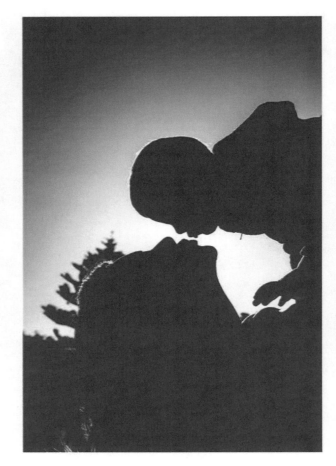

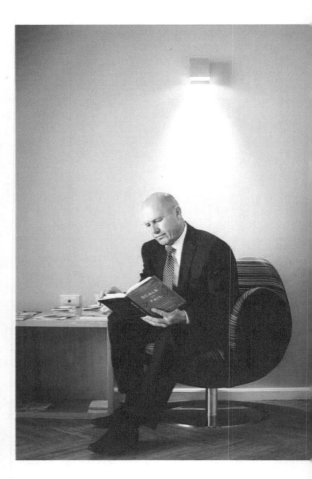

Alan Dinnie

Baby Audrey

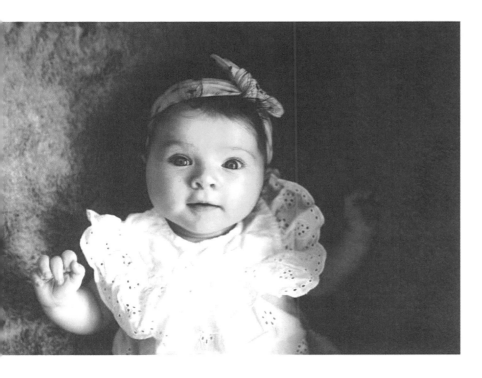

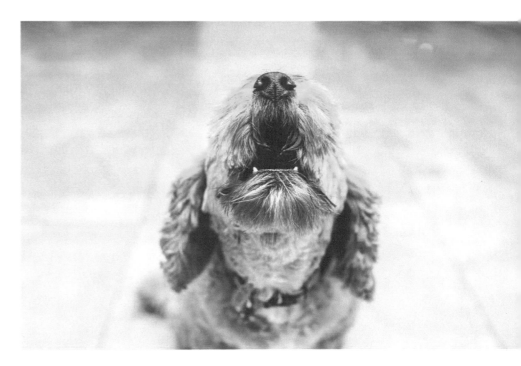

Richie the Doggie

HOME AWAY FROM HOME

The Sarna Family

It is a blessing to have friends like family especially when you are away from home.

My time in Perth wouldn't have been the same without the love and support I received from Abhinav (Abhi), Neha and Neha's mother, Shobha, whom we called 'Durga' out of respect.

The Sarna family showed me that it is never the place but the people you surround yourself with who make the journey balanced and complete. Living with them for a year taught me the value of spending time with family. I learnt what it meant to be a good friend, I also got some practical lessons in bringing up a child!

During the 12 months that I spent with them, what I cherished were the simple, ordinary things that we did together — whether it was catching up with Neha over our 5pm chai and snacks or preparing meals and the weekly house cleaning sessions with Abhi and Durga. The Sarna house was mad, filled with entertainment on an everyday basis — quite like the Big Boss house, we all joked.

My time in Perth was a roller coaster ride right from day one but if there was one person who kept me on my toes, it was Abhi and Neha's two-year-old daughter Kiara 'Kiki' Sarna. She could light up my day with just a smile and as the 1000s of pictures on my phone shall testify, I will never tire taking her pictures…

I know I should stop writing now.

So, Abhi, Neha, Durga, Kiki, Homer and Leia — I don't miss Perth as much as I miss you all. Thank you.

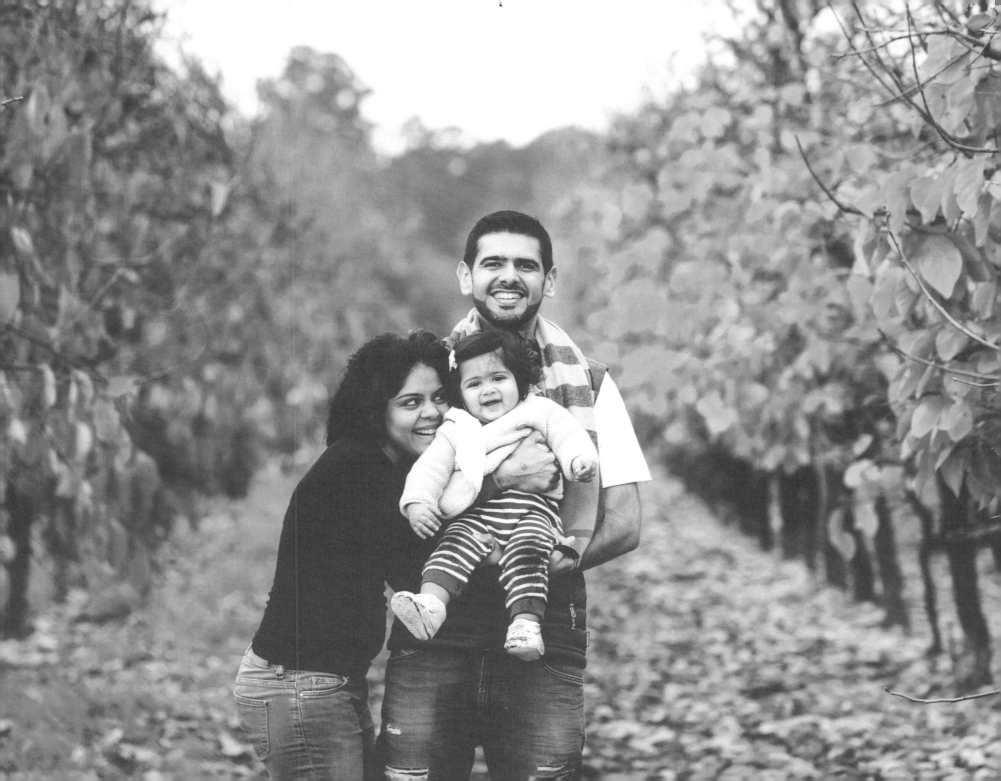

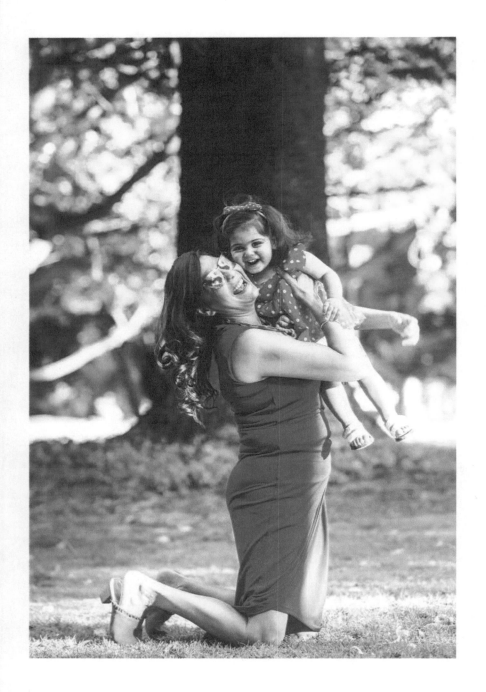

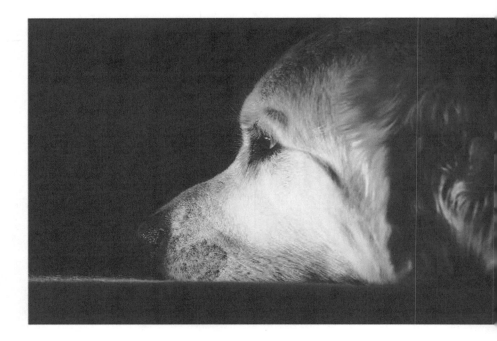

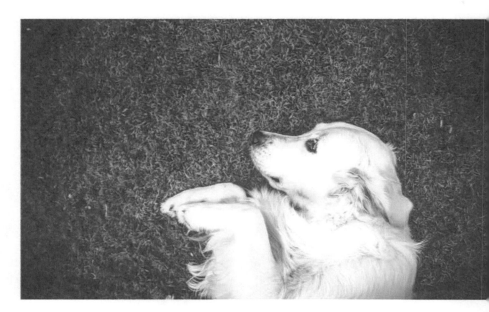

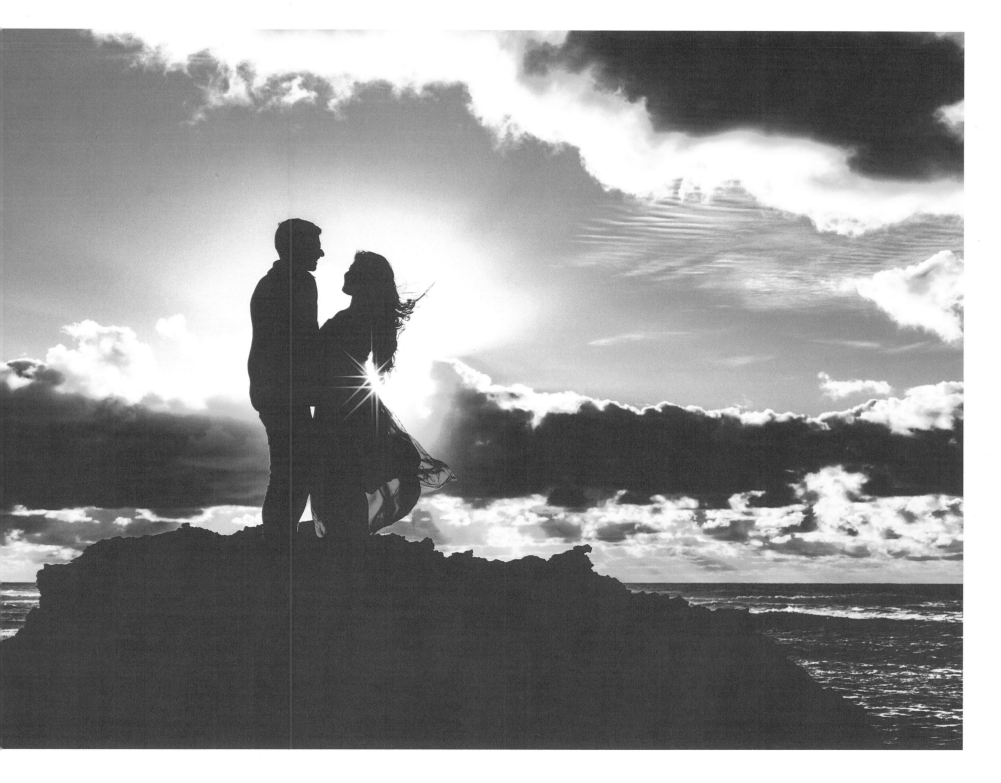

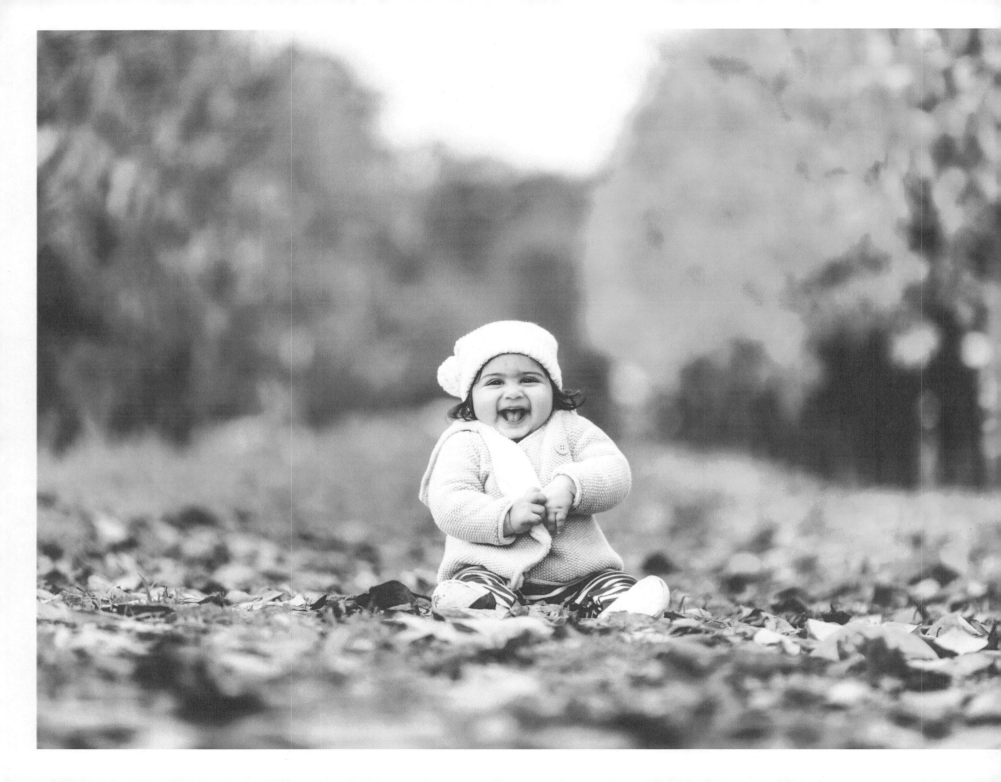

Parabjeet Singh

Parabjeet Singh, or Johny as he is fondly called, is a Bangalore-based photographer who loves to call the world his home. His work has been published in national and international newspapers and magazines. Photography, for Johny, is not about pointing and shooting images. The alchemy he believes lies in knowing your subject and what makes them unique. There is a story in every frame and the learning never stops.